IMAGES
*of America*

# WOODSTOCK REVISITED

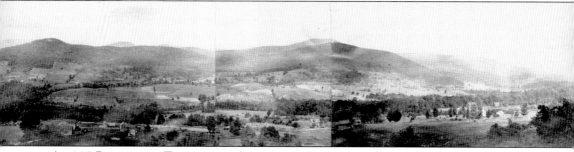

**A 1907 PANORAMA, TAKEN FROM COLDBROOK ROAD.** According to family lore, the Shultises of Coldbrook Road had their origins in Wittenberg, Germany. Roundtop dominates the right, the peak of Tonche is on the left, and Overlook is off in the distance. The first Shultises traded with Esopus Indians along the Ulster and Delaware Turnpike, once a dirt road that snaked its way over Little Tonche Mountain on the way to Kingston. (Courtesy Jeanne Shultis.)

# IMAGES
## *of America*
# WOODSTOCK REVISITED

Janine Fallon-Mower

ARCADIA

Published by Arcadia Publishing
Charleston SC, Chicago IL, Portsmouth NH, San Francisco CA

Printed in Great Britain

Library of Congress Catalog Card Number: 2005928464
1
For all general information contact Arcadia Publishing at:
Telephone 843-853-2070
Fax 843-853-0044
E-mail sales@arcadiapublishing.com
For customer service and orders:
Toll-Free 1-888-313-2665

Visit us on the internet at http://www.arcadiapublishing.com

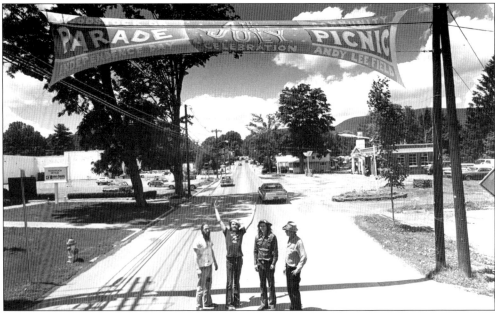

**CELEBRATING THE NATIONAL BICENTENNIAL IN WOODSTOCK.** Pictured here are, from left to right, an unidentified man, Robert Depew Reynolds, Sam Shirah, and Luke Klementis. The social and physical landscape of Woodstock began to evolve when the Woodstock Nation, a spin-off from the 1969 music festival, set down roots in the rural community. Soon there would be a sewer system, formal curb cuts, and sidewalks. Grand Union would leave, but Cumberland Farms would stay. (Courtesy Kiki Randolf.)

# CONTENTS

# ACKNOWLEDGMENTS

I would like to extend a huge Woodstock hug to the following people and organizations who loaned images for this issue: D. J. Stern, the Woodstock Library, Kathy Longyear, the Historical Society of Woodstock, Bill and Peg Baldinger, Ellie Thiasz, Harvey and Rose Ostrander, Joanna Borrero, Marlene Letus, Valda and Phil Eighmey, Ginny and Gene Pettit, Judy Hansen, Joan Mercer, Sue Shader, Doris and Bill Reynolds, Blanche Schmidt, Joanne Anthony, Leigh Ann and Greg VanDeBogart, Ronald Mower, Elaine Ostrander, Irene DeGraff, Howard Shultis, Stanley and Viola Shultis, Kari Hastings, Loren Rose, Muriel Rozzi, Joan Taylor, Helen Mower, Jeanne Shultis, Kiki Randolf, Pixie Brownlee, Gale Brownlee, Fern Malkine, Gayle Donoghue, Phil Naccarato, Helen Mayer, Checka Husted, Kitty Dordick, Bill Heckeroth, Joe Holdridge, Tobie Geertsema, Dominique Storm van Leeuwen aka Vos, Mike Wholey, Stan Longyear, Richard and David Jeffery, Sheron Graver, Theresa Reynolds, Anne Mower, Rich Ostrander, and Barry Wingert. To those of you whose pictures were omitted, your personal communications were invaluable to the caption writing. When I called to inquire about the use of personal pictures for this book, each of you came forth with so many precious pictures; I wish I could have used them all. I was impressed with the warm memories you each hold dear in your hearts. I hope I have been able to transfer some of your personal feelings into the captions.

To my dearest Johnny Mower, who would have predicted, so many years ago, all the wonderful collaborative activities we would share? And the best is yet to come. Colleen Mower Young, your gentle smile and loving, helpful touch has been a big part of so many of my community projects, I wonder what's next? Jason Young, my "CSI" image tracker, you would, at a moment's notice, jump in the car as we went off to identify a mountaintop or long overgrown meadow. Allan and Alexa DuBois-Mower, though the many miles of Route 81 separate us, your enthusiasm and positive energy flowed easily through emails and phone calls. Shelli Mellert, you showed me the challenges of working in the past while living in the present. I am grateful to the messenger who said, loud and clear, go back to what you know: writing and Ireland. My dad, Jack Fallon, you taught me about strength, wisdom, integrity, and the value of learning history.

I have used the following local history writings as resources, and I encourage the reader to visit the library or the bookstore and use the following books to learn more about Woodstock: *From Sunset to Cock's Crow* by Neva Shultis; *A View from the Sixth* by Knutsen and Mower; *The Catskills, From Wilderness to Woodstock* by Alf Evers; *Woodstock History and Hearsay* by Anita Smith; *Woodstock: The History of an American Town* by Alf Evers; *The Vanishing Village* by Will Rose; *Woodstock Gatherings, Apple Bites and Ashes* by Jean Lasher Gaede; and the self-published *Our Family Heritage* by Elsie Vosburgh Rowe.

I also used the following resources: the Kingston Water Department Archives; various mortgage records and obituary collections; various publications of the Historical Society of Woodstock; *Woodstock, Recollections by Recipe*; Woodstock Township March of Dimes, 1967; the 2004 Woodstock Draft Comprehensive Master Plan; federal census records; the Woodstock Library newspaper archive collection; and *Woodstock, Some of Us Were Born There*, an unpublished work by Eileen Lasher Powers.

"History cannot give us a program for the future, but it can give us a fuller understanding of ourselves and our common humanity, so that we can better face the future."—Robert Penn Warren.

# INTRODUCTION

*If you would understand anything, observe its beginning and its development.*

—Aristotle

Many visitors come to Woodstock one weekend a month during the summer season, or families return to the same summer rental for one or two weeks each year. Often the community grows through our visitors, and they decided to purchase a home and stay. As one drives through Woodstock today, the center of town has the look and feel of an outdoor mall. The former Reformed Church parsonage now has its windows filled with pictures of homes for sale in the region. The thriving real-estate industry is selling dreams of a better life to many who wish to escape the concrete and blacktop environment of nearby urban areas. It is a cycle that has been repeated for hundreds of years.

*Woodstock Revisited* will bring the reader into different areas of Woodstock's history, including the National Youth Administration buildings, now the home of the Woodstock School of Art, and the creation of the Kingston water supply system reservoirs. Images were chosen that would represent a landscape that has changed or a building that has been modified or is no longer in existence. Images with people in the foregrounds were chosen as a representative selection of members of a number of Woodstock's early families engaged in daily activities.

The book contains four chapters. It is the author's hope that the reader will be reacquainted with events and people who were or who continue to be important to those of us living in the Woodstock community at large. The upper districts of Wittenberg, Bearsville, Montoma, Willow, Lake Hill, and Shady were populated by large families working the land. The Hamlet of Woodstock continues to be a community center where all Woodstockers come together. Zena, more sparsely settled than the other hamlets, has its own unique rural stories. Chapter Four teases the reader with a glimpse of people from the past who have helped to shape Woodstock's future.

Many talented writers have tackled the task of capturing different facets of Woodstock life. Technology has developed in such a way that the 21st-century reader is accustomed to visual images telling a story. Within the body of many of the captions, the reader will find reference to one or more other local history writings. It is the author's hope that the reader will use *Woodstock Revisited* as a pointer and follow the information in the captions to more in-depth stories and anecdotes about our community.

"Whoever wishes to foresee the future must consult the past, for human events ever resemble those preceding times. This arises from the fact that they are produced by men who ever have been, and ever shall be, animated by the same passions, and thus, they necessarily have the same results."—Machiavelli

These days on the Hill call out for your presence
To reinforce memories and to savor the essence

Of those days long ago when we all ran so free
Scaling hillsides, tending gardens, and climbing the trees
Fetching water and milk, riding ice trucks and all
And then to go swimming in our beloved Sawkill.

New friend Bella enjoys a daily swim
in that most favorite river whose memory never dims.
And dear Poly sits happily out in the sun
with an occasional roll in the dirt just for fun.

Memories of our Trixie abound in these sights
And the peepers keep singing through cool spring nights
The birds nest on the porch up on high
And the wild strawberries bloom in fields nearby.

Our memories are vivid of times long ago
Those summers in Woodstock that we all know
But then you trekked West and a new life did build
And here we are to admire your skill.

—From a poem written by Kari Singsaas Hastings for her sister Randi's birthday *c.* 2003.

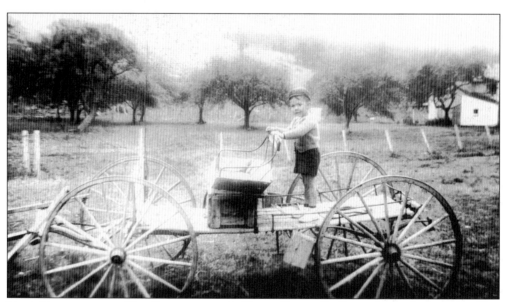

**RICH OSTRANDER AT HIS GRANDFATHER'S FARM.** Harvey B. Ostrander, with the help of his wives Cora and Alfreda, raised a large family on this farm deep in the mountains of Silver Hollow Road. At one time, sawmills were set up on the nearby streams and the family would transport produce to Dave Mazetti in Bearsville for sale. (Courtesy Rich Ostrander.)

# One

# WITTENBERG, BEARSVILLE, YERRY HILL, AND MONTOMA

LESTER AND EDITH QUICK SHULTIS HOUSE. Built in the late 1700s, this house on Coldbrook Road saw three or four generations work the land, plant corn and hay, and keep pigs and sheep in lots on the slopes nearby. Beef and dairy cows grazed the stony land. Grandmother Edith would leave before dawn in a buckboard, taking butter and eggs to Kingston to sell, and would return home at dusk. (Courtesy Jeanne Shultis.)

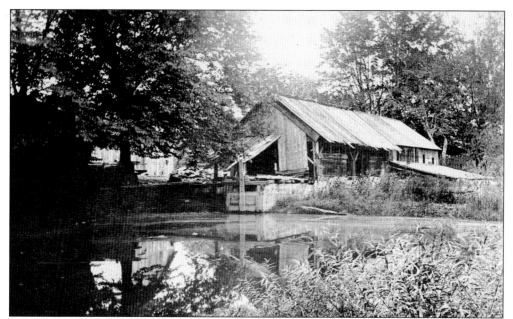

**LESTER SHULTIS MILL BEHIND THEIR HOME, COLDBROOK ROAD.** The Shultis family logged their land around Yankeetown Pond and transported the logs to the mill behind their home on Coldbrook Road. There were three ponds behind the house. Runoff from winter and spring rains was used to power the mill, turning the lumber into boards. Most logging was done in the winter when the ground was frozen. (Courtesy Jeanne Shultis.)

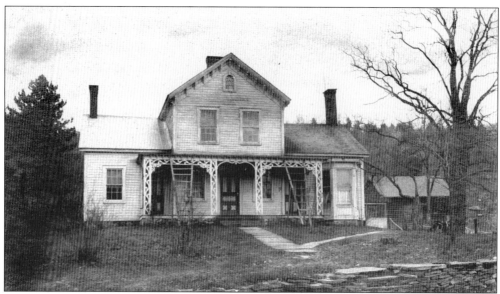

**ROLAND SHULTIS HOUSE.** The home of Roland Shultis was located on Wittenberg Road, just west of the school and Methodist church. "Rolly" Shultis was at one time a town justice, a position which earned him a seat on the town board. The Wittenberg area was once referred to as Yankeetown and later South Woodstock. (Courtesy Jeanne Shultis.)

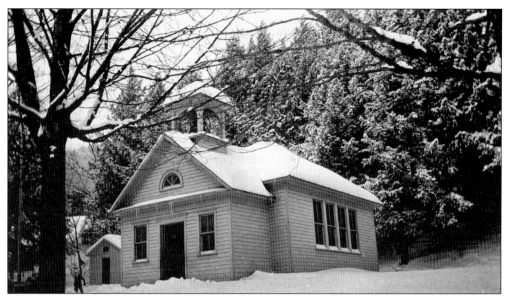

THE WITTENBERG ONE-ROOM SCHOOLHOUSE. Three generations of Wittenberg students received a basic education in this little schoolhouse on Wittenberg Road. There were no busses, snow days, or hall monitors, only a wood stove that was tended to by the older boys and a privy out back. (Courtesy Helen Short Mower.)

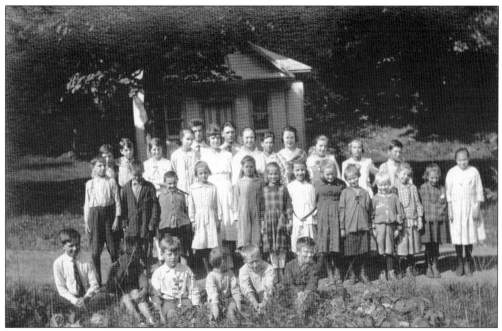

POSING FOR A CLASS PICTURE. Though the names of these students have faded into the past, the faces represent the Shultis, Happy, Short, VandeBogart, Reynolds, and Sagendorf families, to name a few. According to Sherman Short, the schoolhouse was painted red in the 1880s. (Courtesy Helen Short Mower.)

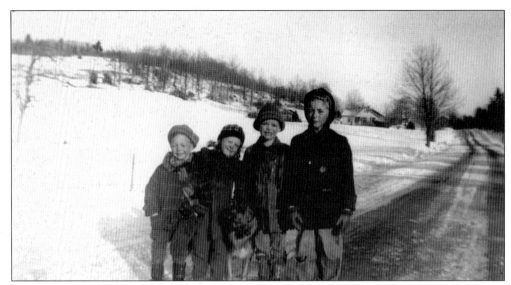

**PLAYING BY THE SCHOOL HOUSE ON A WINTER'S DAY.** The boys bracing for a few more hours' play in the snow are, from left to right, Gordon Walker, Jackie Shultis, Vincent Walker, and Dick Shultis. Behind them is the VanDeBogart house on Wittenberg Road. Sherman Short recalled that the area's name was changed to Wittenberg, after the mountain of the same name, when the post office was established. (Courtesy Leigh Ann Reynolds VanDeBogart.)

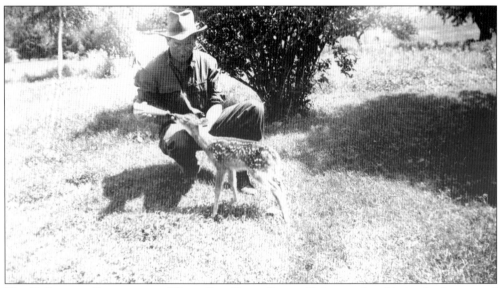

**VANDEBOGART FEEDING THE WEEK-OLD FAWN SUSIE.** Quite comfortable in the forests and mountains he grew up in, Aaron VanDeBogart Jr. worked for 38 years as a forest ranger. He had no concept of clock time, only the time created by the rhythm of nature. He taught others to be respectful of their natural surroundings and often reminded the city people that things are done differently around here. (Courtesy Greg VanDeBogart.)

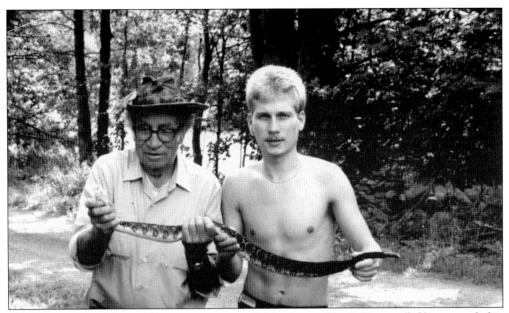

**SHOWING OFF A TIMBER RATTLESNAKE c. 1988.** Aaron VanDeBogart (left) captured this fine reptile in the area of Lewis Hollow, a favorite habitat for snakes due to the remnants of the bluestone quarries. In the old days, he traded snakeskins with people from all over the world. Greg VanDeBogart (right) carries on the skills his grandfather taught him when called upon to relocate the feared rattlesnake. (Courtesy Greg VanDeBogart.)

**THE JACOB AND ELIZABETH HAPPY FARMHOUSE.** Jacob Happy is said to have built this home on Wittenberg Road around 1860. At one time, three generations lived together tending to farm and family needs. His father, Christian Happy, or Happe as he would have been known in Germany, had a farm next door. Jacob's son Frederick, born in 1846, ran a successful lumber business from this location. (Courtesy Ronald Mower.)

SHERMAN AND BELLE SHORT'S FAMILY, WITTENBERG, CHRISTMAS 1935. Pictured here are, from left to right, as follows: (front row) Bill Mower, Joan Mower, and Helen Short Mower; (back row) Hilda Short Jenkins, Ethel Short Barclay, Gladys Short Reynolds, Augustus Barclay, Belle Short, and Sherman Short. Bruce Reynolds is in the high chair. Sherman's first term as highway superintendent was in 1911; men on his crew earned $1.50 for a nine-hour day. (Courtesy Theresa Reynolds.)

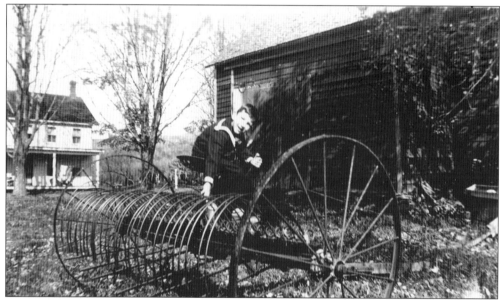

BRUCE REYNOLDS ON THE HAY RAKE AT BELLE AND SHERMAN SHORT'S HOME, 1942. Bruce Reynolds's grandfather Sherman was a lifelong Democrat and ran for supervisor of Woodstock more than once. Bruce Reynolds may have been a little too young to work in the fields, but he would have been a welcome hand with bringing the clothes in that are hanging on the line on the front porch. (Courtesy Theresa Reynolds.)

VOLUNTEER FIRE COMPANY NO. 2, WITTENBERG. The Volunteer Fire Company No. 2 was founded due to an increase in home building in the area. Charter members were Charles Bailey, Edgar Baker, Arthur Barone, Robert Case, Evertt Cashdollar, Roger Cashdollar, Arthur Elting, Joe Forno, Henry and Roger Grazier, Lawrence Hogan, Robert Holsapple, Arthur Louden, Lewis Reynolds, Adam Schreiner, Evernd Short, David VanDeBogart, Kenneth Vredenberg and Dewitt, Harley, Lester, Nelson, Stanley, Vactor, and Victor Shultis. (Courtesy Howard Shultis.)

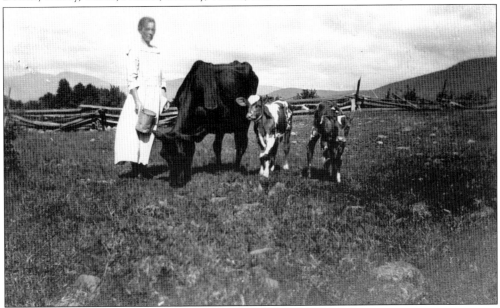

AUNT LIZZIE SHULTIS TENDING THE MILK COWS. The pasture lands nestled atop Baker Road were intersected with old logging trails. There was no need for daily trips to Cumberland Farms or the Wittenberg Store for milk, cheese, butter, or fresh cream. (Courtesy Stanley Shultis.)

**THE PRIZEWINNING PUMPKIN.** Aunt Lizzie Shultis proudly stands beside the largest pumpkin from the garden. If you read a copy of *Woodstock Recollections by Recipe*, you'll find recipes for Gladys Reynolds's pumpkin pie, Florence Peper's Bordeaux sauce, Louise Sully's mustard sauce, and Gladys Feeley's crullers. Sandwiched between the recipes for these tasty treats is a wonderful collection of pictures and anecdotes. (Courtesy Stanley Shultis.)

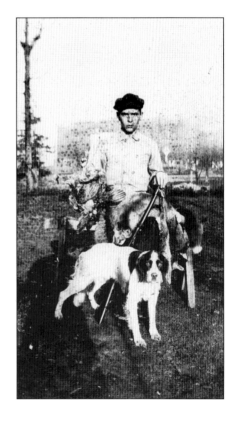

**A FAITHFUL HUNTING COMPANION.** The proud hunter pictured here is an unidentified Shultis, sitting atop a wooden sawhorse. He shows off his bounty from the day's hunt. In his right hand are two wild fowl, on his left leg a fox, and draped on the sawhorse a few rabbits. The dogs were often trained to trail the scent of different game animals. (Courtesy Stanley Shultis.)

**THE LIZZIE AND BERT SHULTIS HOUSE.** Long ago, most of the land from the Wittenberg Fire House to the Wittenberg Store was owned by the William Cramer Shultis family. William Cramer Shultis raised his family in the big house on the corner, and his son Bert built this house just east on Wittenberg road. It is barely visible through the tall pines. All are descendents of Johannes Schultis. (Courtesy Stanley Shultis.)

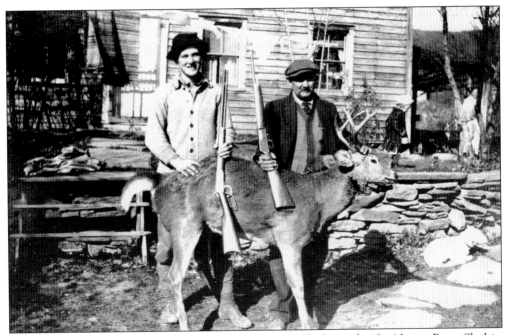

**LIGHT HUNTING HUMOR ON A CRISP FALL DAY.** Isaiah Shultis and wife, Almina Rowe Shultis, raised their family of 11 at this house on top of Baker Road. The children play in the background while their uncles Ed Baker and Dave Rowe clown around before preparing the venison meat for processing. Game hunting was part of life in Woodstock and a way to put food on the table for hungry children. (Courtesy Stanley Shultis.)

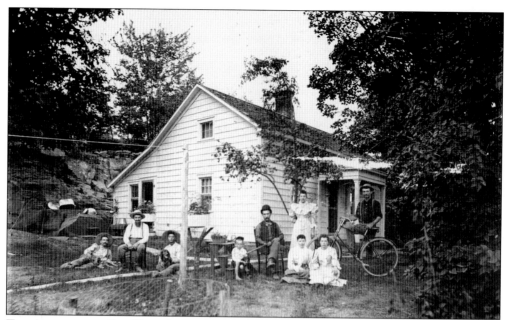

**THE ARTHUR AND IDA HOYT SHULTIS HOMESTEAD.** This homestead on Wittenberg Road was also used as the schoolhouse at one time. Foster Shultis sits second from the left; little Ray sits on the stool steadying his dog; Arthur Shultis, sporting a bow tie, cradles his rifle; and his wife, Ida, stands in the back. Fordyce, brother of Foster and Arthur, stands ready to hop on the bike. The other family members are unidentified. (Courtesy Elaine Shultis Ostrander.)

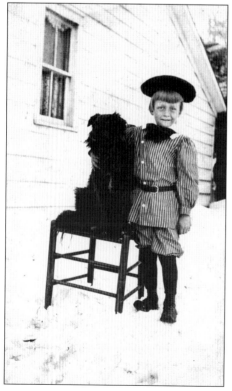

**RAY SHULTIS AND HIS FAITHFUL COMPANION.** What better way to honor your friend than to get dressed up and pose for a picture? Ray Shultis grew up just around the corner from his uncles, Fordyce and Foster Shultis. He and his dog must have run free through the many fields and hills that make up this beautiful hilltop curve on Wittenberg Road. (Courtesy Elaine Shultis Ostrander.)

**ETHEL ELLIOT SHULTIS AND DAUGHTER ELAINE ON A WINTER OUTING.** The home of grandfather Arthur Shultis stood close to Wittenberg Road, but the children had no reason to pay too much attention to the traffic, as there were not many cars going by. The wagon shed, corncrib, milkhouse, and ponds were across the street from the house. (Courtesy Elaine Shultis Ostrander.)

**GERTRUDE SHULTIS ON THE BLUESTONE WALKWAY.** At the crest of Wittenberg hill, this complex of buildings is on the right. One of the older Shultis farmsteads is in the background. Foster and Vida Shultis raised their children, including Gertrude, Victor, and Genevieve, on this sprawling farm. The two-story house across the street, known as Tom's house, was owned by Tom Shultis, son of Fordyce. (Courtesy Elaine Shultis Ostrander.)

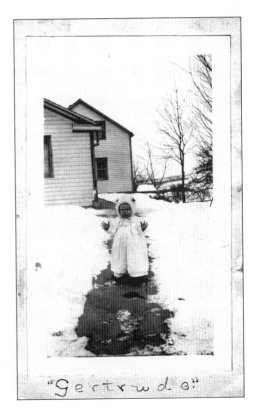

"Gertrude"

**PETER RICKS HOME, COOPER LAKE ROAD.** Gene Shultis and Peter Ricks rest easy in rocking chairs on the porch. The house was built around 1810, and the porch was added around 1910. There was once a smokehouse and stone summer kitchen. Jean Gaede writes that when Theron Lasher lived there *c.* 1920, the family had a "huge ice house where large square blocks of ice carved from Cooper Lake were buried deep in sawdust." (Courtesy Marlene Letus.)

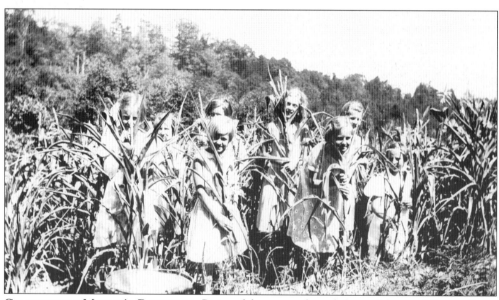

**CELEBRATING MURIEL'S BIRTHDAY.** Pictured here are, from left to right, as follows: (front row) Betty Busch, Dorothy Houst, Muriel Rose, June Houst, and Mildred Reynolds; (back row) unidentified, Doris Reynolds, and Peggy Lasher. Mother Fleda Rose is remembered as a woman who always made time for everyone who came to her door. She absorbed knowledge and espoused wisdom. (Courtesy Muriel Rose Rozzi.)

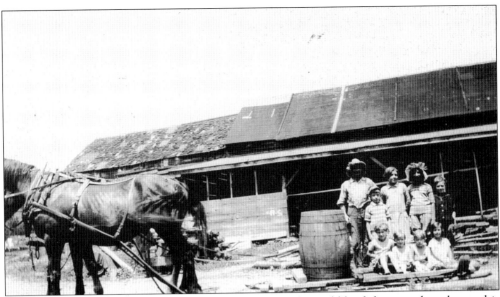

**HITCHING A RIDE ON THE STONE BOAT.** The Rose family would load the water barrel onto this wooden sledge. Then the horse would haul the kid and the water from the spring just under the hill. Pictured here are, from left to right, as follows: (front row) Dino Frank, Muriel Rose, Donald and Durand Rose, and Matina Frank; (back row) Clarence Shultis, Laura Lucas, and Joan Frank Malcom Rose. (Courtesy Muriel Rose Rozzi.)

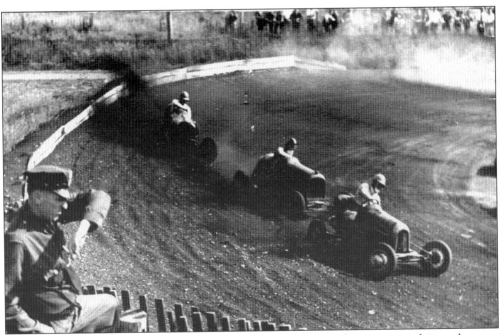

**THE LEGION SPEEDWAY.** Deputy sheriff George Reynolds watches cars speed into the turn on the Legion Speedway that was built on the Theron Lasher farm. Upwards of 7,500 people attended the race held the weekend of June 3, 1938. Race organizers William West and Theron Lasher signed contracts with well-known drivers. Local drivers included Gregory Linden and John Peper. (Courtesy Barry Wingert.)

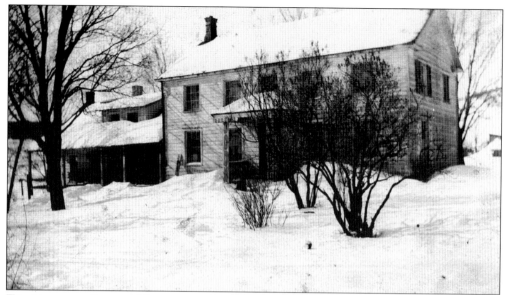

**THE CLARENCE SHULTIS HOMESTEAD, SNOWBOUND.** Built by his grandfather Henry G. Shultis, the homestead of Clarence Shultis on Cooper Lake Road is on the left near Rose Lane. The dwelling has been completely remodeled. According to Jean Gaede, Fleda Shultis Rose's kitchen "radiated marvelous aromas—from a kettle of vegetable soup, a leg of lamb encased in garden fresh mint, and pungent molasses cake." (Courtesy Muriel Rose Rozzi.)

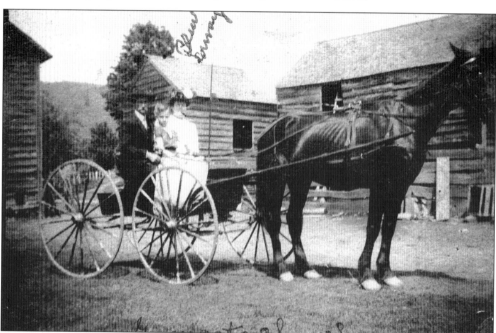

**CLARENCE, "LITTLE FLEDA," AND INA SCHOONMAKER SHULTIS GOING TO CHURCH.** As a young girl, Elfleda Shultis would walk with her friend Theron Lasher down the hill to the spring to draw drinking water for the family. She would dream of a house near the spring. Her husband, Ishmael J. Rose, later made that dream come true by building her a home at the bottom of the hill near the spring. (Courtesy Muriel Rose Rozzi.)

22

**THE BEARSVILLE STORE.** Local customers found a full array of dry goods, produce, tools, feed for animals, and a warm welcome at the Bearsville Store, pictured here when Frank Shultis was the proprietor. The Bearsville Odd Fellow Chapter was formed in January 1886, and the Rebekahs were instituted in 1923; both groups met in the upper floor of the Bearsville Store. Their mission is to serve neighbors in need. (Courtesy Irene DeGraff.)

**THE PETERSEN HOUSE c. 1906.** This view looks south from the Bearsville intersection toward the Bear Café. At one time, John B. Lasher and Christian Baehr were partners in the store. The homes in the background once belonged to Shultis families, and at some point, the women took in summer boarders to supplement their family incomes. The other large homes at the Bearsville corners belonged to the Cam Lasher family. (Courtesy Fern Malkine.)

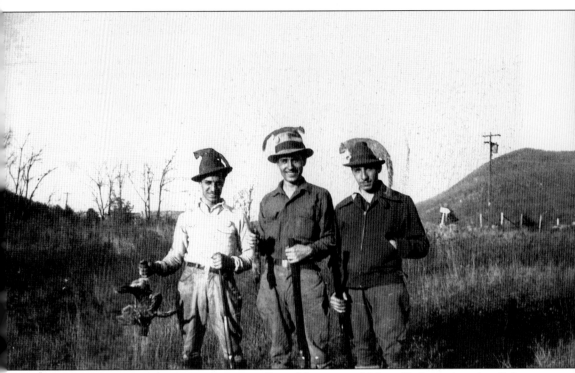

**HAVE THE DWARVES CAST A SPELL ON THE ROSE NEIGHBORS?** Neva Shultis writes that Salo Lasher Emerson's grandmother had 15 children. For help knitting mittens and stockings, she relied on some little dwarves who lived on top of the Lake Hill Mountain. One wintry day, grandmother Lasher asked Christian Baehr to take the sleigh up and gather the things the dwarfs had knit for her. He came to a tiny white house surrounded by pine trees and a walk leading to the front door. He saw a little man and woman in each window, but when he opened the door, two black cats greeted him. (Courtesy Loren Rose.)

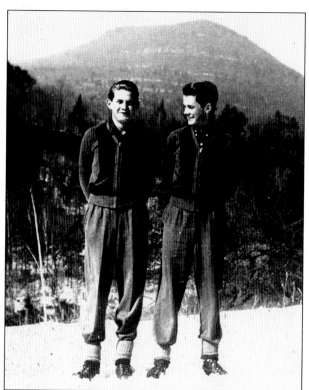

**DONALD AND DURAND ROSE.** The Rose twins are standing on the hill on the west side of Cooper Lake Road where their great-great-grandparents Henry G. Shultis and Maria Sagendorf had their farm. As a child, their father Ishmael and his father joined the family to help with the endless chores in exchange for bed and board. (Courtesy Loren Rose.)

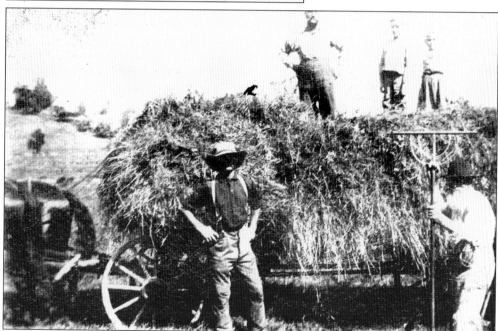

**MEMBERS OF THE ROSE FAMILY LOADING THE HAY WAGON.** There was a rhythm to pitching the hay onto the wagon. First the hay had to be turned with the pitchfork to scare away snakes that may have taken refuge in the windrow over night. Many a young boy had a fright as the snakes slithered through the fresh hay and off the wagon. (Courtesy Muriel Rose.)

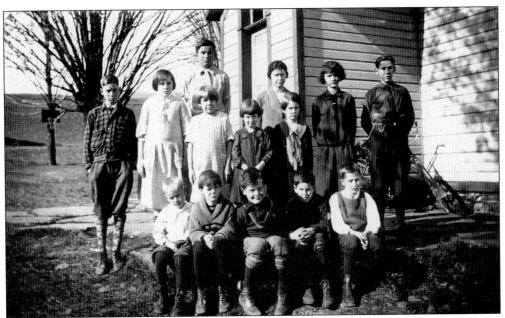

THE BEARSVILLE SCHOOL, TEACHER CHARLOTTE REYNOLDS IN THE CENTER, C. 1920. At one time Bulah DeVall Lasher taught at Bearsville c. 1910. She was a stern disciplinarian. Lasher stopped teaching mid-year, and her replacement (name unknown) lacked experience in the classroom. The frisky kids from Bearsville locked the teacher in the outhouse. The school board brought Lasher back to regain proper school behavior. (Courtesy Blanche Schmidt.)

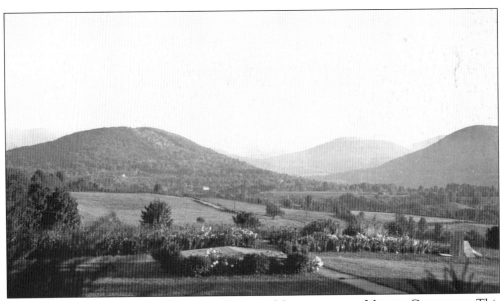

DRINKING IN THE BEAUTY OF CLARENCE SHULTIS MOUNTAIN AND MOUNT GUARDIAN. This image from West Oyaho Mountain Road might inspire one to set up an easel, a stool, and a box of paint or colored pencils. The view is similar to the one that caught the eye of Bolton Brown as he was searching for a place to set up an artist colony. (Courtesy Muriel Rose Rozzi.)

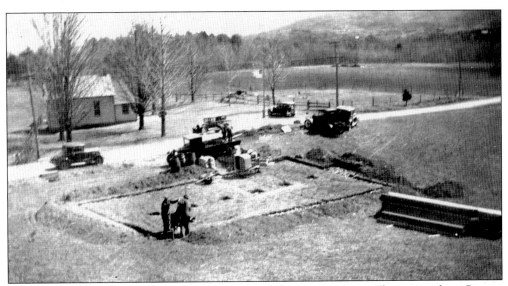

ISHMAL ROSE AND CREW CONSTRUCTING THE ODD FELLOWS HALL. This view is from Cooper Lake Road with the Bearsville School in the background. Throughout the region, open fields and meadows were a prominent part of the landscape. The property was deeded to the Odd Fellows from Scaffer Vredenbergh in 1930. The Rebekahs gained ownership in 1968. Olive Shultis, who joined the Rebekahs in 1937, is the oldest living member. (Courtesy Loren Rose.)

ROY OAKLEY'S GARAGE. Built close to the banks of the Sawkill, this is now the site of Woodstock's Highway Garage. Roy had a little bit of everything for sale at his establishment. According to Alf Evers, Christian Baehr, the German-born storekeeper, bought much of the land in this area c. 1849. (Courtesy Muriel Rozzi.)

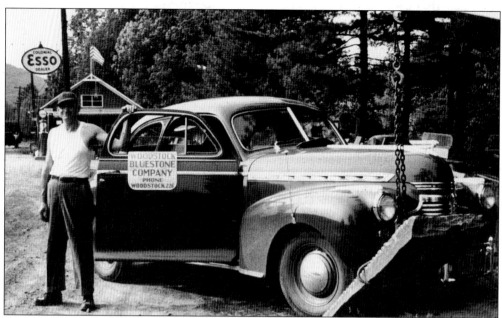

**MOVING THE STONE SLABS TO MARKET.** The proprietor of the Woodstock Bluestone Company, Roy Oakley is parked at the Bearsville intersection, and his garage can be seen in the background. He has a pretty good sized slab of stone ready to hoist with chains. Imagine the mechanics of hoisting stones this size onto a horse-drawn wagon. (Courtesy Kitty Dordick.)

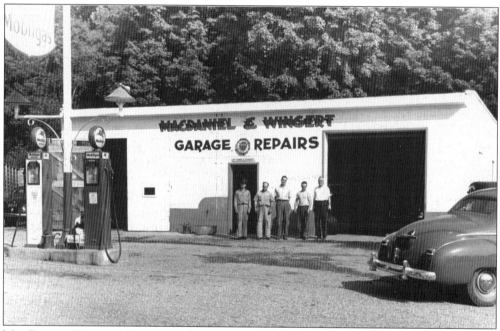

**MACDANIEL-WINGERT GARAGE IN BEARSVILLE.** The men pictured here are, from left to right, Dave DeGraff, Ivan Mallow, John Wingert, Nathan MacDaniel, and Buck Farley. Initially begun for local men to work on their own vehicles, the service station became a popular socializing place for the men of the area. The Harder farmhouse sits to the west. (Courtesy Barry Wingert.)

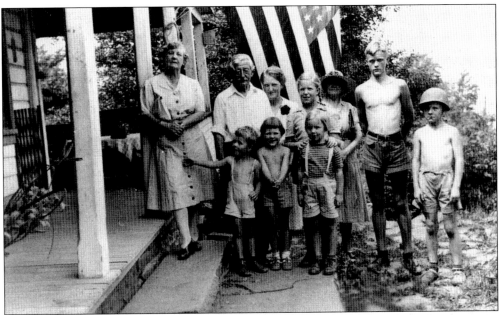

**THE FOUNDERS OF THE DROGSETH COMMUNITY.** In 1922, Eistein Drogseth sought out a quiet country refuge on Yerry Hill where he could pursue his love of painting. The founders of the Drogseth community are, from left to right, as follows: (front row) Eric Larsen, Carole Ann Larsen, and Kari Singsaas; (back row) Maja Drogseth, her brother Eistein Drogseth, Ruby Drogseth, Randi Singsaas, Eistein's wife Christine Drogseth, Aunund Jore, and Ivar Aavatsmark. (Courtesy Kari Hastings.)

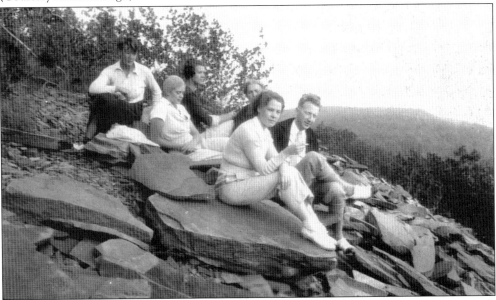

**THE VIEW FROM SNAKE ROCKS.** Visitors were treated to the vast view of Yankeetown, Little Tyce Teneyck, and Tyce Teneyck Mountains. Rumor has it that there were not any rattlesnakes on Snake Rocks. The snakes were across the valley on Overlook. When the children played among the wild blueberry and blackberry patches, they would find garter snakes. The quarry hole was often used for swimming and bathing. (Courtesy Kari Hastings.)

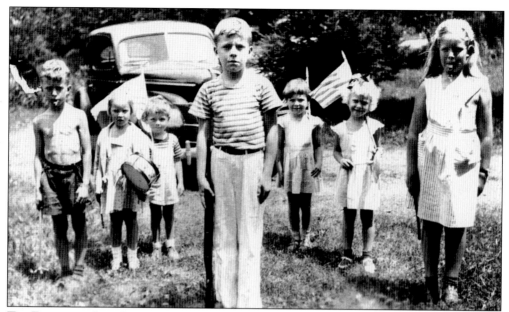

THE FOURTH OF JULY CHILDREN'S PARADE C. 1950. Many women and children stayed the summer atop Yerry Hill. The men would gather on Fridays and drive from New York City to spend the weekends in the quiet hilltop refuge. As part of their celebration of the Fourth of July, the children would march from house to house. Pictured here are, from left to right, Odd Svalland, Kari Singsaas, Eric Larsen, Ivar Aavatsmark, Carole Larsen, Karen ?, and Randi Singsaas. (Courtesy Kari Hastings.)

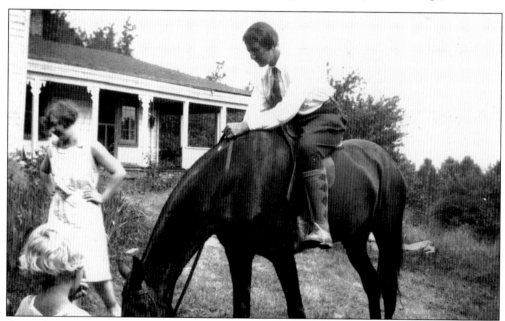

OLGA SINGSAAS RESTING HER HORSE. The families summering on Yerry Hill had vegetable gardens, which they would nourish with water from rain barrels. Left in Woodstock without a car, the children would walk to the Phillips farm toward Montoma for fresh eggs and milk. They did their shopping in Woodstock when the men came home for the weekends. (Courtesy Kari Hastings.)

MANY·HAPPY·RETVRNS·OF·BIRTH-DAY·&·WEDDING-DAY·

**A 1938 DROGSETH DRAWING OF YERRY OUTBUILDINGS.** Many of the farm outbuildings were converted to summer cabins. The children would wait for Dave Mazetti to come up the hill in his ice truck, occasionally hitching a ride as he made his way to the adjoining farms. The children had to make sure to get off the truck before he began the descent back down Yerry Hall toward the Bearsville flats. (Courtesy Kari Hastings.)

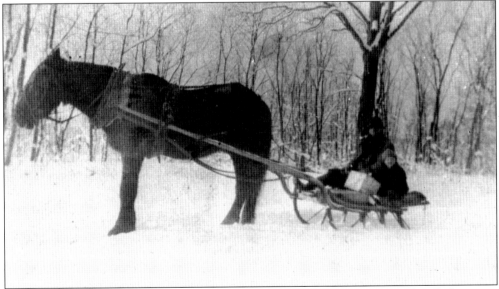

**AARON BONESTEEL DELIVERING MAIL c. 1938.** Little Archie Bonesteel is bundled up on a winter's day as he and Aaron Bonesteel ride the sleigh through "Dark Hollow" between Montoma and Glenford. The children from this area atop Yerry Hill, on the Ohayo Mountain Road side, attended school in Glenford. (Courtesy Irene Shultis DeGraff.)

31

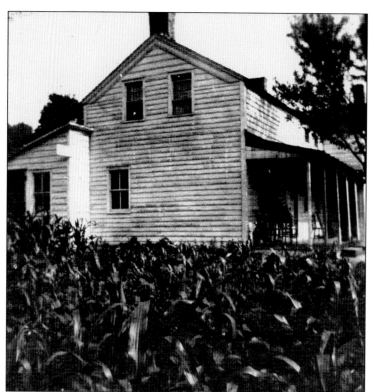

**THE OSCAR DEGRAFF HOMESTEAD c. 1917.** At one time, this building on the corner of Yerry Hill and Ohayo Mountain Road also served as a post office, and the mail was hand-stamped from Montoma. The house was surrounded by cornfields, hayfields, and blueberry patches. (Courtesy Irene Shultis DeGraff.)

**OSCAR DEGRAFF'S SAP AND SMOKEHOUSE.** Alf Evers tells of migrant people known as the "Vly Yonders" who lived seasonally along the Woodstock-Hurley line. Many would travel to Kingston selling brooms, baskets, and native berries gathered from the land along Snake Rocks and Yerry Hill. This smokehouse was built in the early 1900s. (Courtesy Irene Shultis DeGraff.)

**CLYDE DEGRAFF AND CLYDE DEGRAFF JR. BAILING HAY, 1963.** The methods have improved but the need for favorable weather conditions remains the same. The Degraffs are laboring near the homestead of Oscar Degraff. (Courtesy Irene Shultis DeGraff.)

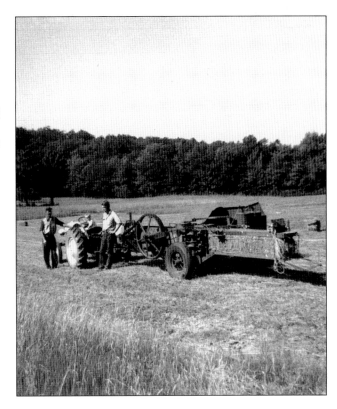

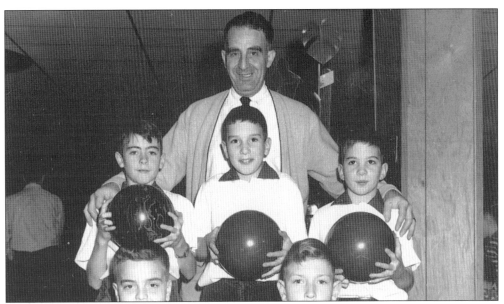

JOE FORNO AND THE SATURDAY LEAGUE CHAMPIONS AT THE WOODSTOCK BOWLING LANES. Forno's Woodstock Pharmacy sponsored many youth activities, including bowling teams. The Woodstock Lanes provided local youth with a place to socialize as well as convenient indoor physical exercise. Though the building is now a small manufacturing plant, the scent of the bowling lane oil lingers in the offices and shipping and receiving areas. (Courtesy Kiki Randolf.)

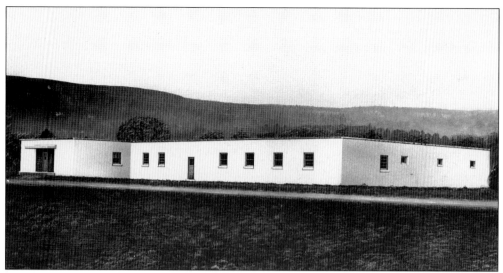

**THE JOSEPH MARR LAMP FACTORY, BEARSVILLE.** Joseph Marr was a jobber for a lampshade company, with an office in Bearsville. Alice, his wife, proposed that she design lamps for the couple to sell. They built the factory around 1953, and it became the source of a lovely line of lamps, as well as an important employer for local people. (Courtesy Joanne Marr Anthony.)

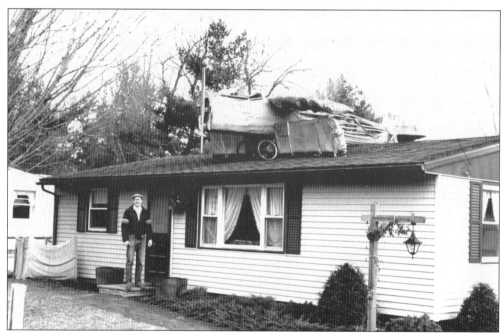

**MILT HOLSAPPLE, SURPRISED BY AN AIRPLANE ON HIS ROOF.** The first homes in the Bearsville Gardens went up in the mid-1950s. For $6,000, a home in the development was an affordable place to settle and raise a family. All the neighbors knew each other, and summertime was accented with block parties and friendly hijinks. Fifty years later, a home in this quiet neighborhood can be bought for $160,000. (Author's collection.)

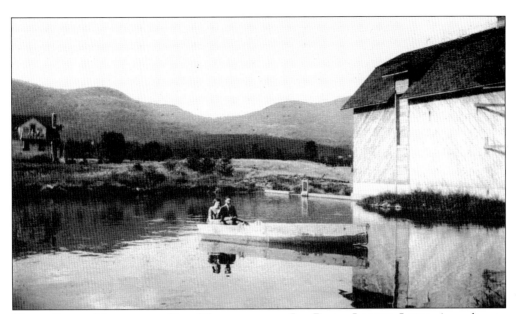

**HELEN SHORT MOWER AND BILL MOWER ON THE ICE POND, LASHER LANE.** According to Neva Shultis, Shaffer Vredenberg recalls: "Every time I drive along the Bearsville Flats, I think how they used to look when I was a boy. Fine farms . . . with oats and rye tall by July and every barn full of good cows; and the mountain was cleared halfway up to the top." (Courtesy Helen Short Mower.)

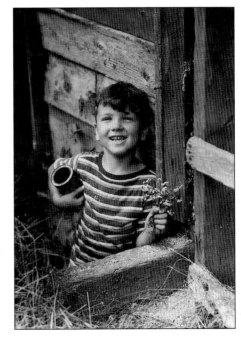

**YOUNG BRUCE REYNOLDS BRINGS GIFTS TO HIS MOTHER GERTRUDE SHORT REYNOLDS.** It is a wise child who brings his mother flowers in one muddy hand and a can of wriggly fish worms in the other. The ice barn is loaded for the season, and the sawdust drifts through the cracks in the chestnut boards. (Courtesy Theresa Reynolds.)

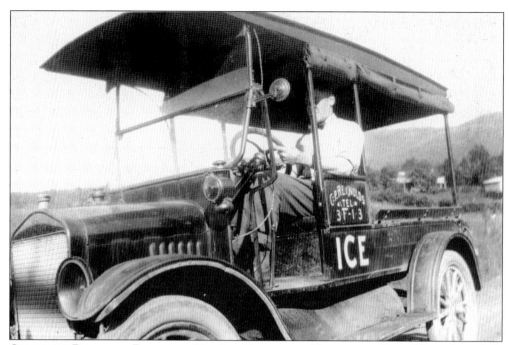

CLARKSON REYNOLDS READYING HIS ICE TRUCK FOR DELIVERIES. Reynolds made a daily run through town to deliver ice. With the growing popularity of electric refrigeration, this occupation would fall by the wayside. (Courtesy Leigh Ann Reynolds VanDeBogart.)

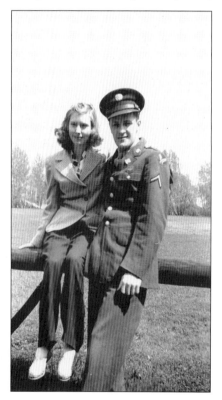

RICHARD JEFFERY AND LOIS LASHER JEFFERY. Richard Jeffery joined the Air Force and served in the European theater during World War II. Those who were left behind during wartime did what they could to support their friends and neighbors overseas. Anita Smith writes that before Pearl Harbor, local women collected over 810 pounds of aluminum for salvage in a cage on the village green. Some even tossed in their favorite cooking pots. (Courtesy Richard Jeffery.)

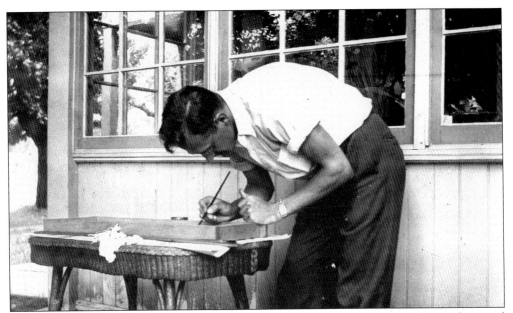

**LANDSCAPE ARTIST RICHARD JEFFERY WORKING OUTSIDE HIS STUDIO.** The meadows and rolling hills surrounding this studio provide passersby with a glimpse of the vistas that drew the Byrdcliffe artists to Woodstock in 1902. At one time, DeVall Road went up over the hill toward the stream, providing access to the farms near Yerry Hill. (Courtesy Dave Jeffery.)

**THE CHAUNCY DEVALL CIDER MILL.** Jean Gaede wrote, "In the fall of the year, farmers driving two-hoss wagons loaded with empty oak barrels and bags of apples would create a parade of wagons headed for the mill. They were determined, dedicated men, driving past the Main Street abodes of strait laced citizens in the Prohibition era, with apples to be rendered into cider." (Courtesy Dave Jeffery.)

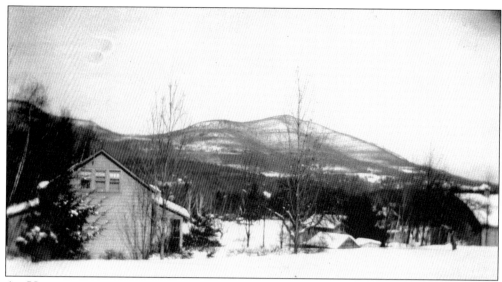

**AN UNSPOILED VIEW OF OVERLOOK, 1948.** Looking north from the apple orchard, the snow-covered fields of the lower slope of Overlook are visible. The view has changed somewhat. When driving into town at night, we now see the face of Overlook dotted with lights from dozens of million-dollar homes erected in the area over the past 20 or 30 years. (Courtesy Dave Jeffery.)

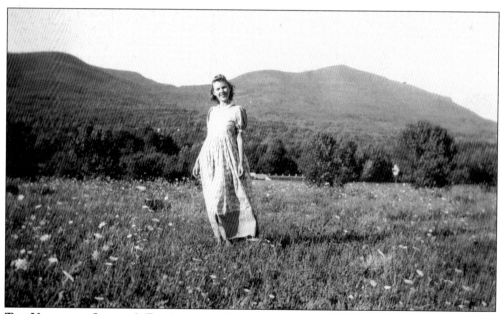

**THE VIEW FROM LASHER'S FIELD ON THE BEARSVILLE FLATS.** Lois Lasher Jeffery frolics among the Queen Anne's lace. One of the last vast open spaces within the village area, this farm was once part of the Philip Ricks farm and orchard. Later, Riseleys and DeValls would work the land. (Courtesy Dave Jeffery.)

# *Two*

# WILLOW, LAKE HILL, AND SHADY

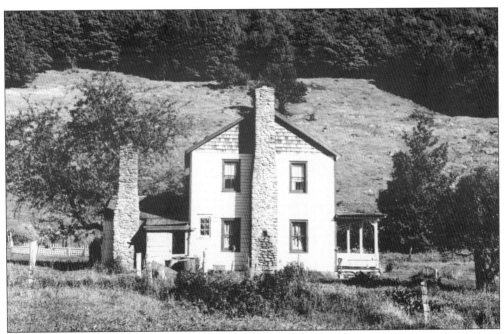

THE HARVEY BURHANS OSTRANDER HOMESTEAD, SILVER HOLLOW. Over two miles in from the junction of Silver Hollow and Eighmey Roads, members of the Ostrander family have lived near this homestead since the late 19th century. The summer kitchen had a woodstove and kerosene lamps to work by. The cellar had a spring running under it, where food supplies could be stored in winter and an occasional trout was caught. (Courtesy Harvey W. Ostrander.)

**THE STONY CLOVE TRAIN TRESTLE AT EDGEWOOD.** Harvey B. Ostrander, with the help of summer boarders, drove his team of horses to Edgewood to pick up supplies that were unavailable at the local general store. The supplies were purchased in Kingston and delivered by train. Teams of horses were used to plow fields in the summer and haul logs and bobsleds over snow-covered roads in the winter. (Courtesy Harvey W. Ostrander.)

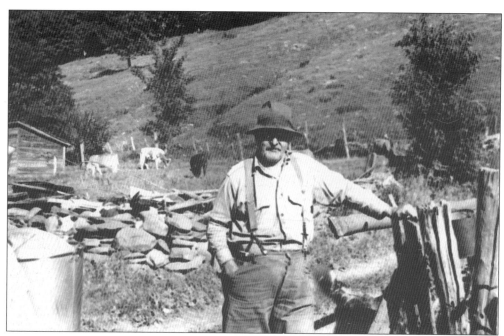

**HARVEY B. OSTRANDER, PAUSING A MOMENT.** Most days, farmers worked from sunrise to sunset. A self-sufficient family, the Ostranders grew most of their own food, raised cows and chickens, and hunted local game. Mother Alfreda's meal of fresh trout, hand-dug potatoes, strawberries, and buttermilk rewarded a day's hard work. Single men were hired on for board and a week's wage to help work the farm. (Courtesy Harvey W. Ostrander.)

**HARVEY W. OSTRANDER AND FRIEND PLAYING BY SILVER HOLLOW ROAD.** Many roads in the upper districts of Woodstock did not see blacktop until the late 1940s. Harvey and his siblings walked the two miles over the mountain to a one-room schoolhouse in Edgewater (Lanesville). (Courtesy Harvey W. Ostrander.)

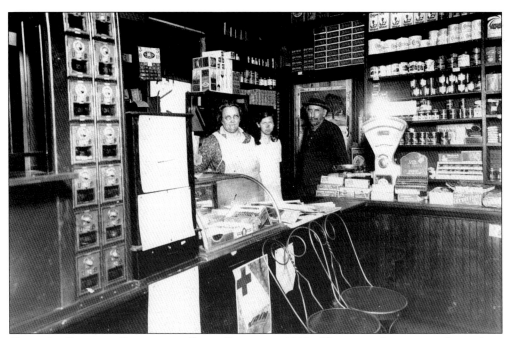

**KELLER'S GROCERY STORE AND POST OFFICE c. 1933.** This general store was located on Eighmey Road by the bridge. Local residents shopped here for items such as tea, snuff, and tobacco. Locals usually had their own barrels of apple cider and vinegar. Pictured here are, from left to right, Viola Mills Keller, Grace Shultis Howland, and Fred Keller. (Courtesy Marlene Howland Letus.)

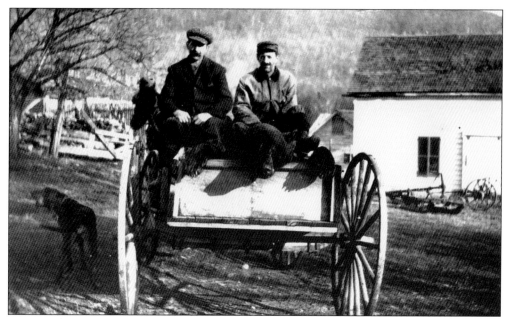

HUNTING BLACK BEAR NEAR WILLOW c. 1921. Oscar Howland and Harvey B. Ostrander climbed in the wagon and propped up this 400-pound bear. The hunting dogs circle around the wagon, and the horse waits patiently for its next instruction. Occasionally bears were captured alive. The dogs would then be trained to follow the scent of the live bear. (Courtesy Marlene Howland Letus.)

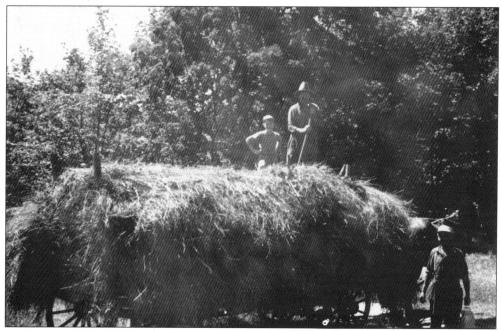

PREPARING TO PUT THE HAY IN THE BARN. The weather is not always your friend when getting the hay in. A family would need a few days of dry weather before they could cut the hay, let it dry in the field, and then heap it into windrows. If it got wet, the process started again. Only dry hay could be stored in the barn. (Courtesy Harvey W. Ostrander.)

**JULES SIMPSON, POSTMASTER, LAKE HILL POST OFFICE.** This post office was located on the south side of 212 near the corner of Cooper Lake Road. Simpson served as postmaster from 1927 to 1947, and he and his wife, Madge Howland Simpson, sold boots, general food items, and some clothing. (Courtesy Joan Watson Mercer.)

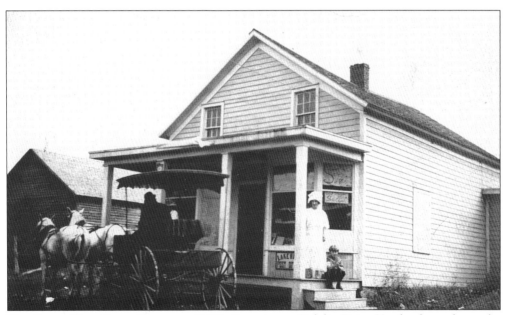

**THE LAKE HILL POST OFFICE c. 1900.** Postmistress Eulalia Daisy Howland stands on the porch, and her son Earle Watson is seated on the steps. Late one night, Howland heard horses racing by the post office and then noticed the building was on fire. She managed to rescue the mail, but not the building. (Courtesy Joan Watson Mercer.)

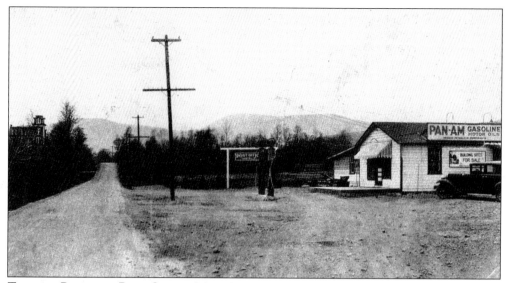

**TRADING POST AND POST OFFICE, MINK HOLLOW ROAD AND ROUTE 212.** The signs on the building advertise the sale of Pan-Am gasoline and building lots. Slab lumber was stored in the field just west of the trading post. Off in the background to the left is the Macready Tavern (at other times, Morrison's Tavern and Lake Hill House). (Courtesy Joan Watson Mercer.)

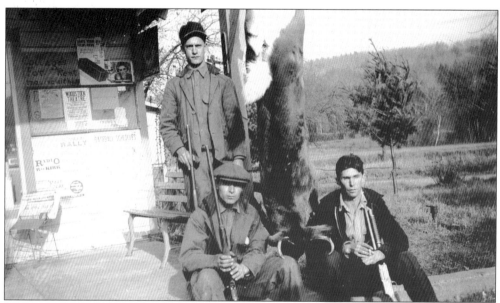

**ON THE PORCH AT THE LAKE HILL STORE.** Barnet Howland stands next to the white-tail deer. Bob Howland and Harrison Lapo join him. Over the years, the white-tail deer population has increased its nuisance factor due in part to the disappearance of the meadows. (Courtesy Marlene Howland Letus.)

A FINE LITTLE BOY, WILBER MILTON HOWLAND. Born August 1861, son of Egbert and Helen Ophelia Wilber-Howland, Wilber Milton Howland took sick with scarlet fever during the winter of 1864. His father hiked into the woods on Olderbark to gather slippery elm for a tonic to cure his son. Wet and weary from his hike, he returned home to find that the child had died in his absence. (Courtesy Joan Watson Mercer.)

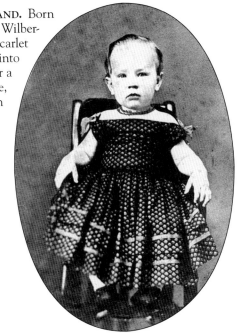

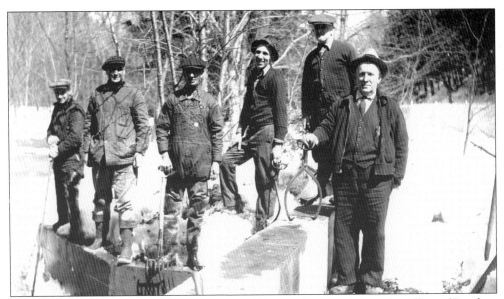

WORK CREW CLEARING THE ICE AT THE MINK HOLLOW INTAKE. When the village of Rondout and the city of Kingston combined in 1872, the need for clear, pure drinking water became a priority. In 1893, the Kingston Water Company leased the water from Cooper Lake, and in 1897, plans were set in place to divert the Mink Hollow stream into Cooper Lake, now Reservoir No. 3. (Courtesy Kingston Water Department.)

**OPHEMIA HOWLAND AND FRIENDS ALONG MINK HOLLOW ROAD C. 1900.** A mile or so beyond the DEC turnaround is the area where, Alf Evers writes, in the late 1700s, " the Schoharie Road, through Mink Hollow to the valley of the Schoharie was proposed." This is where Mink, the slave, set up his cabin and Pat Cunningham, the Irishman, raised his large family. (Courtesy Joan Watson Mercer.)

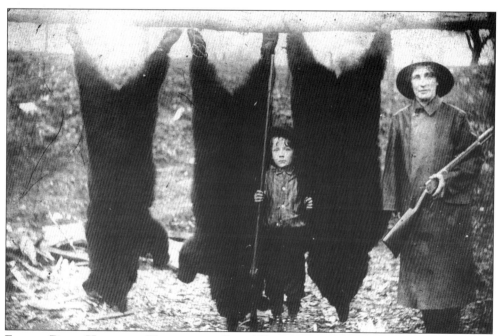

**EULAIA DAISY HOWLAND-WATSON AND EARL WATSON WITH BEAR CARCASS.** According to Alf Evers, hunting families like the Howlands sold bear meat at 15¢ per pound. Hides would have been used for rugs and other functional items. Little Wilber, who died of scarlet fever, was Eulaia's brother. (Courtesy Joan Watson Mercer.)

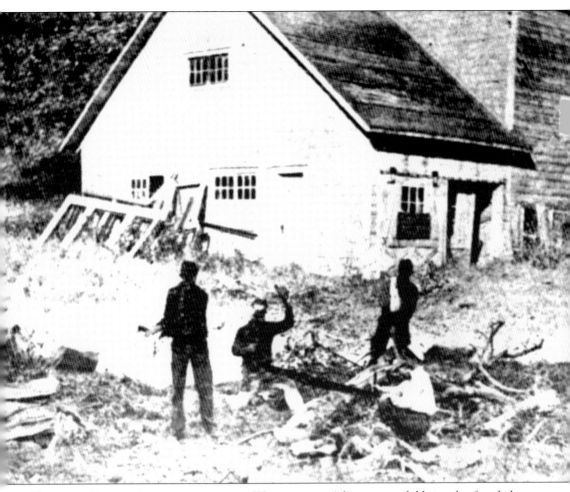

**NATIONAL YOUTH ADMINISTRATION IN WOODSTOCK.** After intense lobbying by first lady Eleanor Roosevelt, Franklin Delano Roosevelt created the National Youth Administration, a Depression-era program for unemployed youth, by executive order in 1935. The site on Mink Hollow Road, known as the Wilber Mill and Crane property, was chosen by a committee that included Towar Boggs, Tomas Penning, Anita Smith, Jessie Cooper, Sherman Short, and Jules Simpson. (Courtesy Kingston Water Department.)

**SPRING WORK IN MINK HOLLOW, 1954.** Pictured here are, from left to right, Romain, Junior, Herb, Ro, Terry, and Harry Wilber. They are working in the area where Neva Shultis writes that the witch Becky cast a spell on Pat Cunningham's cart. The road was bone-dry, but his strong oxen couldn't budge the cart. He had to cut a willow switch and beat the wheels to break the spell. (Courtesy Sue Shader.)

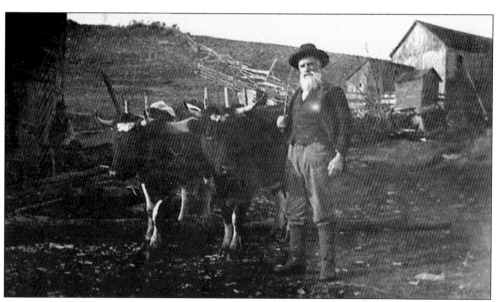

**RUFUS VANDEBOGART TENDING HIS OXEN ON THE MINK HOLLOW FARM.** Greg VanDeBogart's great-great-grandfather is said to have been in possession of the famed Cooper Lake Stone. Alf Evers tells us that it was said to be over five feet long and weighed up to 700 pounds. (Courtesy Greg VanDeBogart.)

PAULINE KEEFE WILBER HAULING LOGS.
With her children in tow, Pauline Keefe
Wilber would often put in a full day's
logging in Mink Hollow. Kingston Water
Department rules that were put into effect
in 1893 impacted the way of life in the
hollow. The streams and ponds were to be
kept free of all wastes from sawmills, cider
mills, tanneries, or beer vaults. (Courtesy
Sue Shader.)

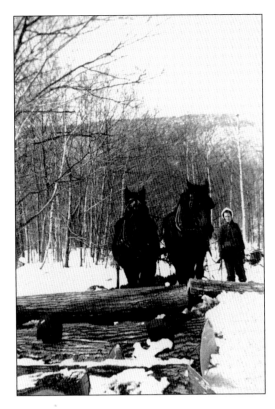

EARLE WATSON'S MILL c. 1940. This noisy,
free-standing mill behind the present Lake
Hill post office was far enough away from
the Cooper Lake watershed. According
to Alf Evers, the politicians who turned
Cooper Lake into a reservoir for purely selfish
motives did not know they were preserving
and improving a glorious hint of the look
of the primeval Catskills. (Courtesy Joan
Watson Mercer.)

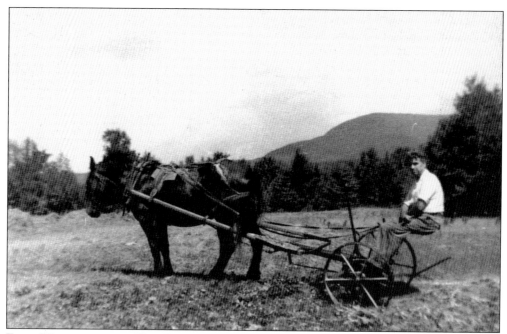

EARL WATSON ON THE HAY RAKE c. 1956. There once was a field on the north side of 212 across from the entrance to Cooper Lake Road. Not far from here, a gang of down renters captured John Baehr Lasher, bound his hands, hauled a cask of tar from Peter Sagendorf's nearby barn, and commenced to tar and feather Lasher. (Courtesy Joan Watson Mercer.)

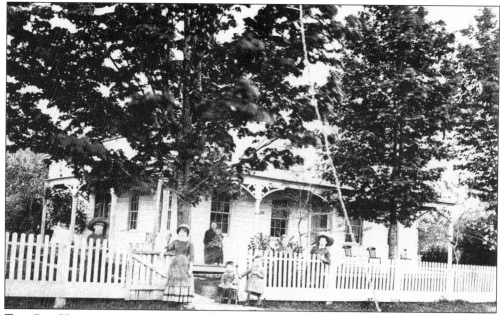

THE OLD HOMESTEAD. Egbert and Helen Ophelia Wilber Howland moved their family from Mink Hollow to this dwelling across from the Lake Hill Trading Post. The couple had 13 children, three of whom did not live to adulthood. Helen is remembered by family members as an untrained folk artist. An image of one of her paintings can be found in Anita Smith's *History and Hearsay*. (Courtesy Joan Watson Mercer.)

**Ellsworth MacDaniel Portraying a Down Renter in the Sesquicentennial.** During the mid-1800s, many of the three-life lease farms reverted back to the Livingstons. A regional rebellion sprang up. Anita Smith wrote, "The Woodstock down renters chose as their leader Asa Bishop, to be known as Black Hawk. Members pledged themselves to secrecy, to loyally uphold each other and obey their leader." (Courtesy Barry Wingert.)

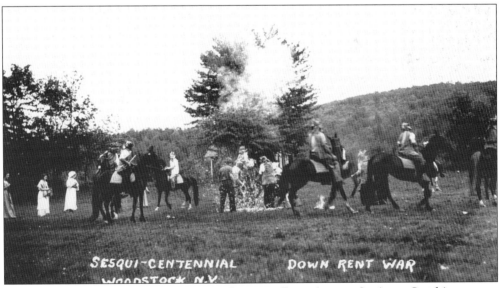

**"Calico" Indians Getting Ready to Go on a Ride Along.** In Anita Smith's account, the "Calico" Indians blocked the road with a farm wagon, scaring the sheriff as he attempted to return to Kingston. Local men would ride the roads and harass their neighbors. "The horns will toot from door to door while old tin pans will clatter; there's Indians scalping all around, For Lord's sake what's the matter!" (Courtesy Barry Wingert.)

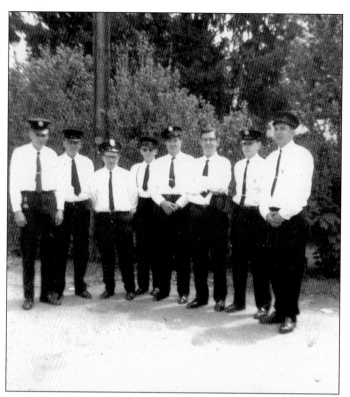

**MEMBERS OF THE LAKE HILL FIRE COMPANY NO. 3.** Founded in 1956, the Lake Hill Fire Company No. 3's pancake breakfasts began on Valentine's Day of 1982. Chip Chase is credited with the idea as a way to thank the auxiliary for their assistance during and after fires. Posing before heading into town for the parade are, from left to right, Al Ostrander, Dick Peters, Connie Maclary, Fred Fischer, Henry Eighmey, Phil Eighmey, and Paul Shultis. (Courtesy Valda Eighmey.)

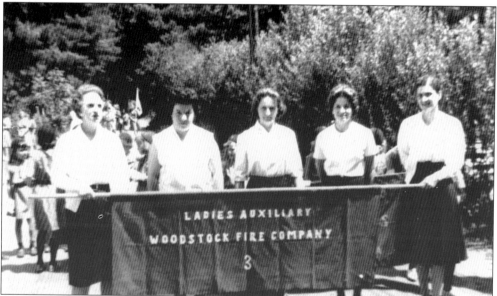

**LADIES AUXILIARY FIRE COMPANY NO. 3 IN THE PARADE.** Pictured here are, from left to right, Ellen Taylor, Evelyn Shultis, Lenetta Lapo, Kate Ostrander, and Elizabeth Eighmey. Auxiliary members would turn out for night fires and supply the firemen with coffee and hot food. During the summer months, the women would bring cold drinks and sandwiches to the fire sites. Today they serve at the fire department breakfasts. The group was founded in July 1960. (Courtesy Valda Eighmey.)

NEARING THE COOPER TOLL STATION ON A SNOWY AFTERNOON. After severe snowstorms, many back roads went unplowed for three or four days. Anita Smith tells us that when William M. Cooper acquired this property as part of Great Lot No. 25 of the Hardenberg patent, it included the 833 acres upon which the glass factory stood as well as the 30 acres including the gristmill near the Stillwell-Stagg house. (Courtesy Matthew Leaycraft.)

YOUNG PETER LEAYCRAFT RIDING AT THE RESERVOIR NO. 3 OPERATOR'S HOUSE. Jacob Cooper bought land near here from Eugene Livingston in 1843 and set up another sawmill. This dwelling was part of the Cooper family farm, and in 1893, the Kingston Water Department leased the waters of Cooper Lake from William F. Cooper. (Courtesy Matthew Leaycraft.)

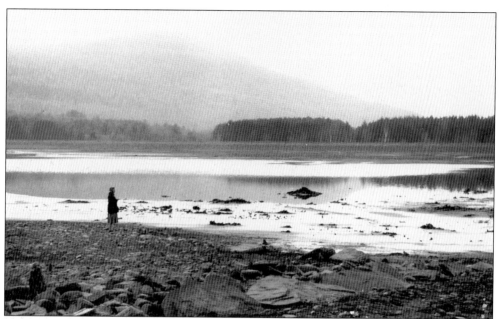

RESERVOIR NO. 3 SUFFERING FROM THE SEVERE DROUGHT OF 1957. Alf Evers wrote in the *Woodstock Week*, "At Sheering time, sheep were washed in the lake, in the winter men caught pickerel through holes in the ice while crowds of young people skated. Horse races held on the ice drew crowds of people to watch James Vosburgh race a French Canadian trotter." (Courtesy Gene Pettit.)

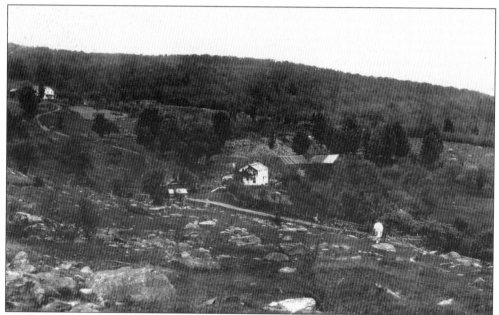

THE VANDEBOGART AND DAVIS FARMS, HARMATI LANE. There is evidence of old bluestone quarries up in this area, and members of the Charles Davis family are also known to have farmed up in Mink Hollow. Alf Evers writes that in 1927, Rufus VanDeBogart was cited along with Ralph Whitehead for farming activities that might pollute the Sawkill watershed. (Courtesy Historical Society of Woodstock.)

54

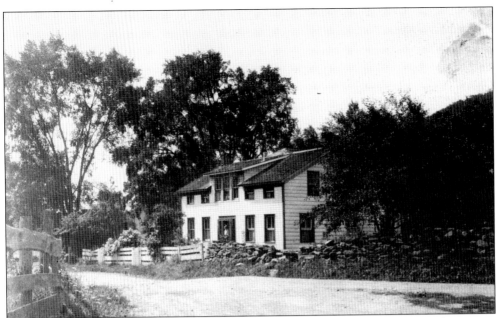

**MOUNT GUARDIAN VIEW HOUSE.** The Fred Reynolds family home and boarding house was once a two-family house for glass factory workers and their families. A summer boarder at the Reynolds home would wake to a hearty farm breakfast and the sounds of the Sawkill bounding over the rocks. Slowly the sun would creep over "Uncle Marty's Mountain," the family name for Mount Guardian. (Courtesy Bill Reynolds.)

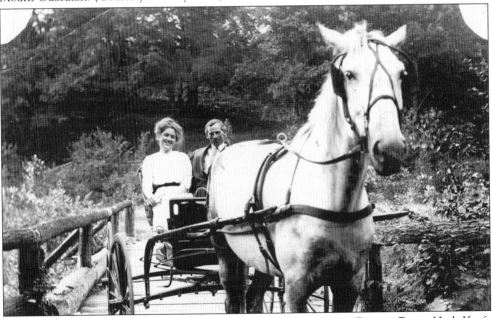

**BEATRICE HOWLAND KEEFE AND HERB KEEFE ON A HORSE-AND-BUGGY RIDE.** Herb Keefe was elected to the town board and served two terms. Life was not always easy and carefree. Beatrice Keefe died soon after giving birth to the couple's fourth child. The remnants of a glass factory community behind the Keefe homestead have long since vanished. The factory closed in 1824, and many workers moved to Bristol. (Courtesy Sue Shader.)

**THE VIEW FROM THE MacDANIEL ROAD BRIDGE.** The Sawkill flows past the old glass factory barns, headed through Shady toward Bearsville. Anita Smith writes that in 1836, the glass factory recorded 50 people employed and 1,500 boxes of window glass for sale. For years, locals would unearth remnants of glass slag in the area. (Courtesy Kingston Water Department.)

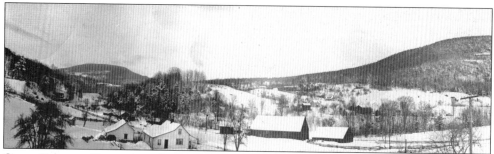

**GLASS FACTORY BARNS AND REYNOLDS HOMESTEAD.** In winter, people would gather around the glass workers, gleaning wisdom from stories and warmth from the furnaces. According to Alf Evers, in January 1811, an ad was posted: "Wood chopper's take notice! Constant employ at glass factory and liberal price given in cash for chopping wood by the cord or acre." (Courtesy Bill Reynolds.)

**MAKING THEIR WAY DOWN CHURCH ROAD.** Natalie MacDaniel Sonnenberg, Elizabeth Reynolds MacDaniel, and Margaret Mallow walk toward their homes on the snow-packed road. Winter was a time for rejuvenation before spring. There was no need for salt and sand to completely clear the roads of snow. (Courtesy Barry Wingert.)

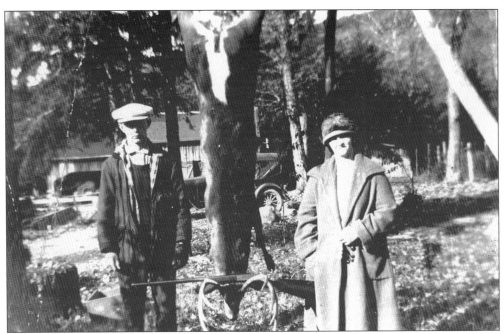

**BEAR HUNTER OSCAR HOWLAND'S WIFE AND SON EYEING A TASTY GAME DINNER.** Bob Howland and his mother Emma Ricks Howland are seen here near their home on MacDaniel Road. Locals tell a story about Gus Mosher, who walked home through Lake Hill from Kingston. One evening he heard a panther howling on the mountain. He took off his shoes and sped lickety-split to the safety of his home. (Courtesy Marlene Howland Letus.)

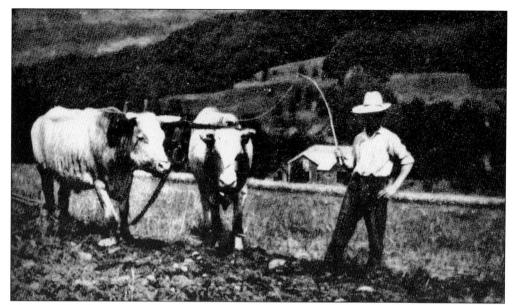

**MARTIN MACDANIEL AND HIS OXEN IN THE FIELDS BELOW INDIAN HEAD.** Martin MacDaniel's grandmother Betsey Booth MacDaniel married James MacDaniel in 1826. She was known as an herbalist and natural healer. Her family lived in "The Plaines," a clearing in the shadow of Indian Head Mountain. James MacDaniel, originally from Scotland, moved to the area to cut lumber for the glass companies. (Courtesy Fern Malkine.)

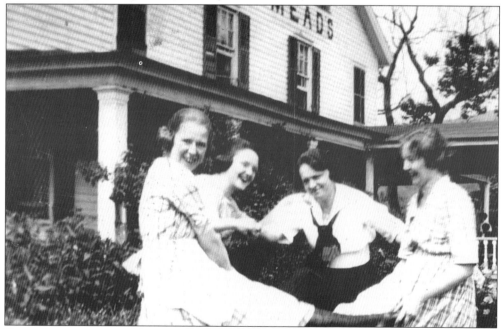

**GIRLS FROLICKING AT MEADS AFTER A DAY'S WORK, 1921.** Marguerite Burhans Mallow, Elizabeth Reynolds MacDaniel, and two friends walked up to the boardinghouse each day. Their positions as housekeepers put them in contact with artists and wealthy business people from around the country. Their mothers and fathers would have had the same experience with visitors at the Overlook Mountain House. (Courtesy Barry Wingert.)

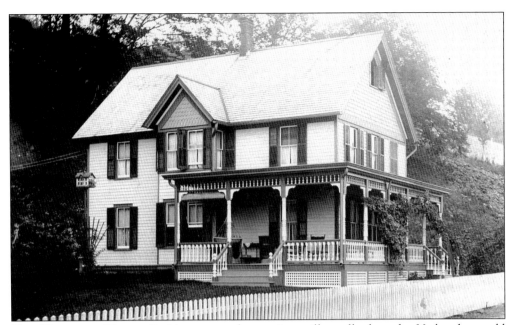

THE VOSBURGH HOUSE. Residents near the turning mill recall when the Vosburghs would dust out their barn before haying time and celebrate the good weather with barn dances. In later years, children walked home from school up Harmati Lane past the Vosburgh house and stopped at the mill to converse with the workers. They would refresh themselves with water from a nearby spring. (Courtesy Blanche Schmidt.)

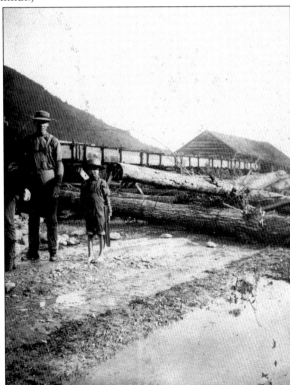

THE MILLRACE FOR THE REYNOLDS SAWMILL c. 1931. William E. Reynolds and his brother Charlie set up this sawmill just downstream from the Vosburgh turning mill. They processed hemlock, maple, and other hardwoods native to the area. Census records tell us there were a dozen or so mills in this area around 1820. (Courtesy Blanche Schmidt.)

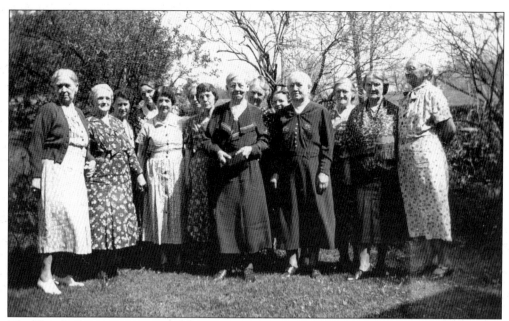

**THE KING'S DAUGHTERS, 1939.** The Trusting Ten Circle of Shady was organized by Mrs. John Miller in 1889. It began as a fellowship organization for mothers and daughters, fostering a spirit of cooperation and fellowship. Pictured here are, from left to right, M. Burhans, J. Cooper, C. Reynolds, E. Russell, C. MacDaniel, unidentified, A. Cashdollar, L. Reynolds, M. Guzman, M. Gridley, E. Vosburgh, A. Simmons, ? Bonesteel, and C. Hoyt. (Courtesy Valda Eighmey.)

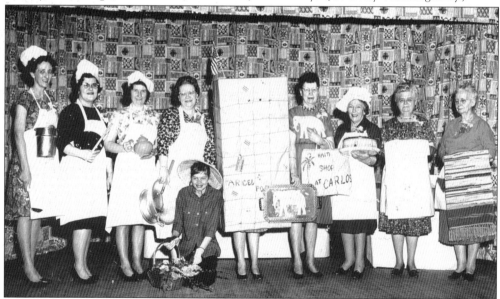

**THE DIAMOND ANNIVERSARY KING'S DAUGHTERS, 1951.** The purpose of the King's Daughters was "not to be ministered to but to minister." The August roast beef dinner and July fair at the Shady Church were fundraisers for the King's Daughters. Tables at the July fair featured braided rugs, crocheted quilts, white elephants, and baked goods. Pictured here are, from left to right, Phyllis Howland, Vaughn Hafele, Lenetta Lapo, Ida MacDaniel, Kris Peterson, unknown, Kay Vosburgh, Margaret Shields, Margaurite Carnright, and Alice Stone. (Courtesy Ginny Pettit.)

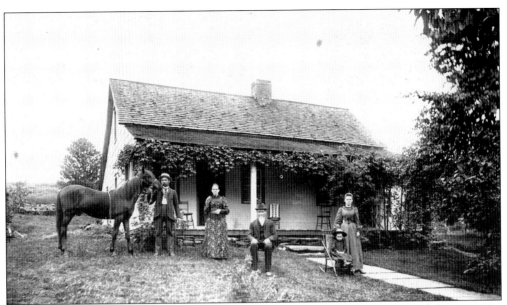

THE ALFRED REYNOLDS FAMILY HOMESTEAD c. 1910. Pictured here are, from left to right, William Reynolds, his mother Hannah Hoyt Reynolds, his father Alfred Reynolds, and his wife Emma Hemmingway Reynolds. The child may be Frederick, son of William and Emma. The house sits overlooking the site of the Bristol Glass Factory at the intersection of Reynolds Lane and Church Road. The Reynolds family's home appears on maps of the glass factory area in 1830. (Courtesy Bill Reynolds.)

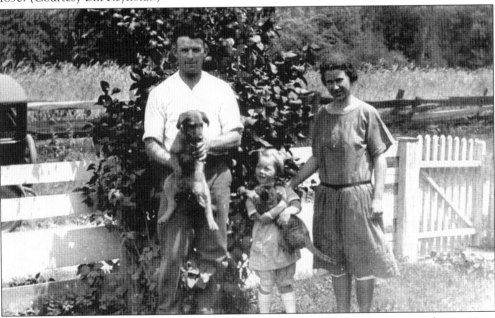

BLANCHE, CHARLOTTE, AND FRED REYNOLDS IN FRONT OF BOARDINGHOUSE. At one time, the hill behind the Mount Guardian View Boardinghouse was full of homes for the glass workers and their families. The summer season was the busiest of all. Boarders seeking a break from the city heat and artists studying at the various art schools made up the majority of boarders. (Courtesy Blanche Schmidt.)

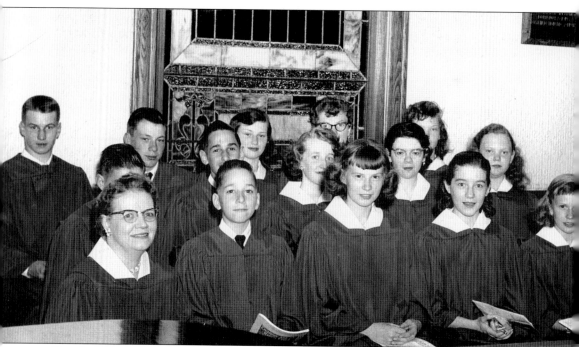

**THE SHADY CHURCH CHOIR.** The Shady Church was founded to serve the glass workers in Bristol around 1871. Local families tell the story of Martin Booth, who supported his family by cutting shingles. His avocation was preaching, and every Sunday, he walked to Wittenberg to preach in the morning, to Little Shandaken to repeat his sermon in the afternoon, and back to Bristol for the evening service. He would then trek back to his home up in "The Plaines." Pictured here are, from left to right, as follows: (front row) Ida MacDaniel, Walter Bollenbach, Valda Lapo-Eighmey, Betty Lou Allen, and Pat Lapo; (middle row) Jackie Hall, Fred Bollenbach, May MacDaniel, Ginny Carnright, and Marie Wilber; (back row) Gene Pettit, Phil Auchmoody, Edna Auchmoody, Ethel May Wilber, and Francine Wilber. (Courtesy Gene Pettit.)

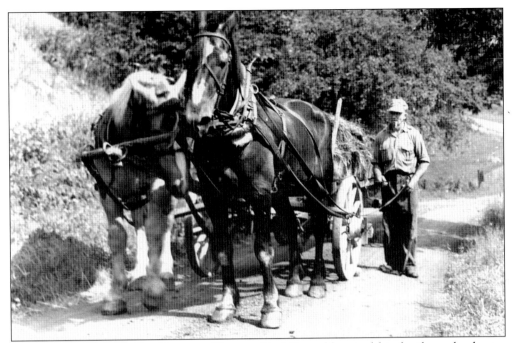

**FRED REYNOLDS AND HIS BELGIAN HORSES.** Fred Reynolds raised his family on land once owned by a descendant, Peter Reynolds, who was secretary of the Ulster County Glass Manufacturing Company. Anita Smith wrote that Peter rented 11 houses, drew 500 cords of wood from Hutchin's Hollow, and is credited for riding 7,049 boxes of glass to Poughkeepsie. (Courtesy Blanche Schmidt.)

**THE OLD GLASS FACTORY TAVERN.** The first level of this dwelling was once located near the intersection of the Glass Company Turnpike and Route 212. According to Fordyce Burhans, it was hauled to this site, just on the left on Reynolds Lane, with a team of oxen and rolled on logs. In its next life, the dwelling would become a summer boardinghouse and residence. (Courtesy Joanna Borrero.)

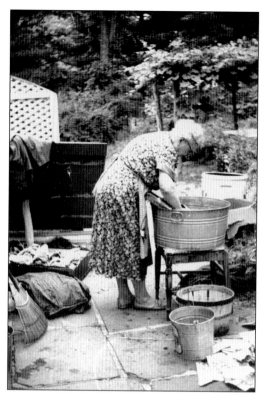

**WASH DAY IN SHADY.** Women's work is never done. Anna Mauser does the family wash on a bright summer day. Additions were made to the old glass factory tavern, and in the 1930s and 1940s, Mauser took in summer boarders. The women who ran boardinghouses had a telephone network to coordinate places to stay when their houses ran out of vacancies. (Courtesy Joanna Borrero.)

**CHARLIE REYNOLDS, GRISTMILL OPERATOR.** Charles Reynolds married Carlottta Britt, and they raised 10 children in the Shady valley. His gristmill was near the Stillwell house, at the entrance of the Glass Company Turnpike. His grandfather Herman Reynolds served two terms as supervisor for the town of Woodstock, once in the 1840s and again in the 1850s. (Courtesy Barry Wingert.)

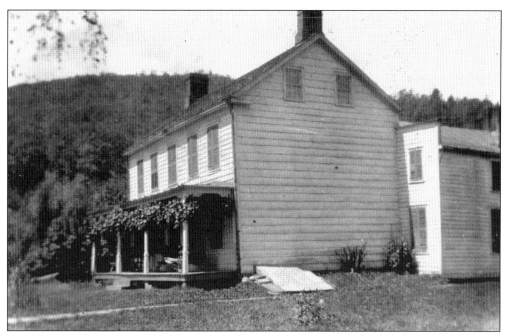

**THE BRISTOL GLASS FACTORY MANAGER'S HOME.** Also known as the Charlie Reynolds house, this home on Reynolds Lane was built around 1830. Bankruptcy in 1846 ended its function as a home for the glass factory manager. The dwelling, now known as Brock's, was the residence of artists Brock and Louise Brokenshaw. (Courtesy Barry Wingert.)

**MARIE WINGERT IN FRONT OF A GLASS FACTORY STORE.** Once its days as the glass factory store were over, this structure became a polling place and later the studio for well-known artist Brock Brokenshaw. Glass factory ledgers are archived by the historical society and offer a glimpse of the daily needs of local workers. (Courtesy Barry Wingert.)

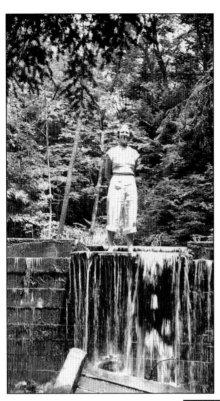

**MARGARET MAUSER ATOP A KINGSTON WATER DEPARTMENT INTAKE IN SHADY.** As the Sawkill tumbles out of Echo Lake, a portion of the freshwater was diverted into the pipes for eventual delivery to Reservoir No. 1 in Zena. Erosion caused by a 1955 hurricane made this area less than perfect for drawing water. (Courtesy Joanna Borrero.)

**FISHING IN THE SAWKILL IN SHADY.** The water intake is just barely visible in the background. This area of the Sawkill provided a beautiful natural setting for people to gather and picnic, swim and socialize. The large boulders were easily covered with towels for basking in the warm sun. The deep water pools in this area of the stream bed were inviting and refreshing. (Courtesy Joanna Borrero.)

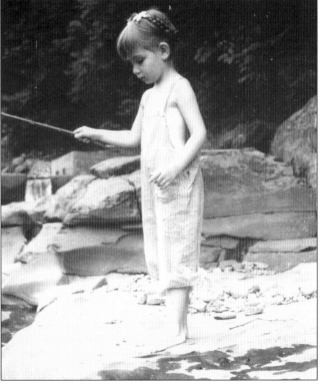

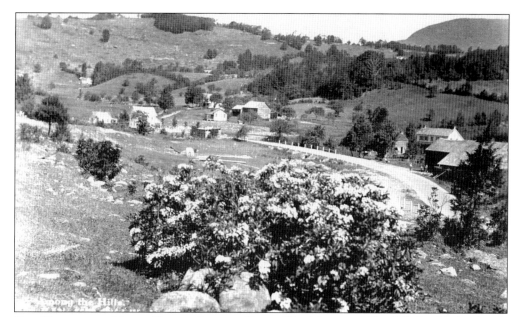

**THE HARRY AND HAZEL KELLER SHULTIS FARM.** The Harry and Hazel Keller Shultis family sold ice cut from Cooper Lake in the winter. In the summer, the scent of fresh-mown grass wafted in through the windows. The tinkle of cowbells could be heard by hikers up on this ridge. (Courtesy Fern Malkine.)

**ON GRANDMA'S BLUESTONE FRONT STEPS c. 1942.** Sisters Elaine and Marlene Howland show off their hats for grandmother Hazel Keller Shultis. The farmhouse is known to be around 200 years old. A working farm for many years, their grandfather tended cows, horses, and chickens in this beautiful setting. When the wind was right, the Shady Church bell could be heard on Sundays. (Courtesy Marlene Howland Letus.)

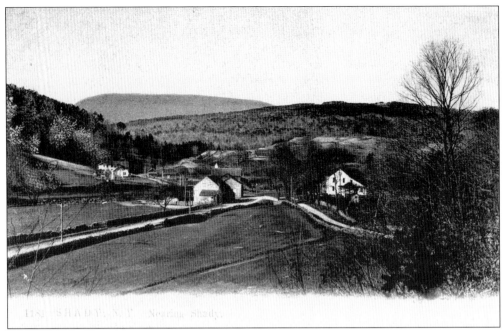

**VIEW OF THE STILLWELL HOUSE.** Stephen Stillwell was a top official of the Bristol Glass Company and is reported to have had slave quarters on his property. Later the Peter Reynolds family lived there and the turnpike road cut past the Reynolds and Elting gristmill, between the barns and on up to Shady. The front walkway is made of giant bluestone slabs. (Courtesy Fern Malkine.)

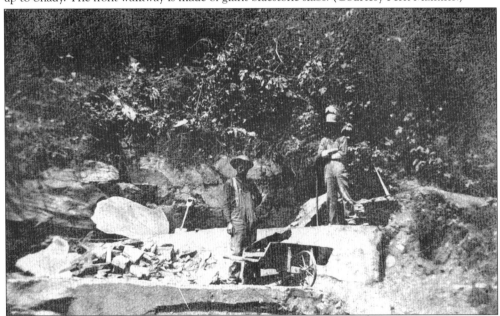

**ABE ROSE AND HIS HELPER IN THE QUARRY OFF COOPER LAKE ROAD.** The little cart hardly looks sturdy enough to handle a 20-ton stone being hauled out of Shady in 1881. Quarry work was a dangerous profession, and transporting the stone had its own hazards. A wagon transporting a stone once crashed through Riseley's bridge, killing a horse and injuring the teamsters. (Courtesy Muriel Rose Rozzi.)

**BARNEY HOWLAND IN HIS STONE YARD.** With the discovery of cement, the need for bluestone sidewalks decreased significantly. Stonecutters of Howland's generation focused on supplying stone for decorative walls, walkways, and other smaller jobs. The tools of the trade changed, as saws now incorporated diamond edges to cut the stone. (Courtesy Marlene Howland Letus.)

**THE HENRY P. VANDEBOGART-BIRGE SIMMONS FARM.** Many recall the Simmons farm on Striebel Road and the sheep in the fields. Agnes Simmons was the daughter of Christian Baehr. There is a story about travelers, heading for Lake Hill and Willow, who wished to avoid the toll at the Harder Hotel and toll station. They cut along VanDeBogarts, thus bypassing the toll. (Courtesy Fern Malkine.)

**STUDENTS OF THE LAKE HILL SCHOOL C. 1950.** Posing for a year-end picture are, from left to right, as follows: (front row) Ernie MacDaniel, Edwin Wilber, teacher Freyda Watson, Buzzy Carl, Chippy Chase, and Robert ?; (back row) Ginny Carnright, Ethel May Wilber, Nancy Lattamore, Carol Howland, Ethel Lattamore, Joan Watson, Marlene Howland, Elaine Howland, unidentified, Susie Wilber, Herbie Wilber, Paul Shultis, and Bobby Lattamore.

# *Three*

# WOODSTOCK TO ZENA

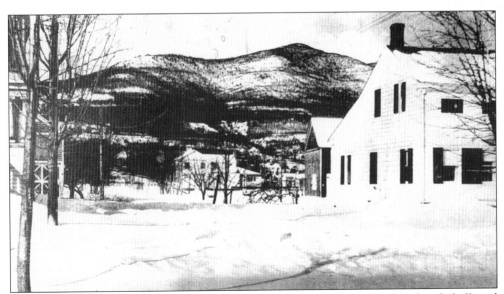

LOOKING NORTH DOWN ORCHARD LANE. The porch of the Methodist church hall and parsonage is visible on the left. The Overlook Mountain is in the background. The old hotel and bar of Sam Elwyn is the building seen at the right of the photograph. There are apple orchards behind the Elwyn Hotel. (Courtesy Kiki Randolf.)

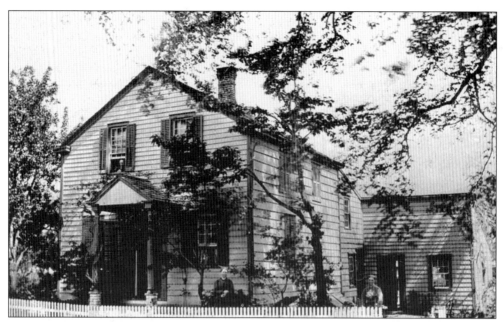

ELIZABETH LASHER CLOUGH'S HOUSE. Victor Lasher's sister Elizabeth's house on the north side of Tinker Street once served as sheds for the undertaking establishment. It was hauled to the street and remodeled into a home when Elizabeth married Francis Clough. At one time, Woodstock had two undertaking establishments. Hyp Bovee was the other undertaker in Woodstock, and his location was closer to the center of town. (Courtesy Joe Holdridge.)

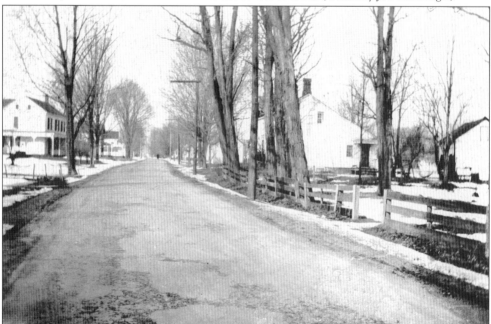

TINKER STREET LOOKING WEST c. 1925. The Woodstock Library has preserved the original section that was once Dr. Larry Gilbert Hall's home and office. The section is recognized today by the little painted gold stars on the trim. Records show that Dr. Hall built his home in 1812, and his wife, who was the daughter of William Harder, lived there until 1850. (Courtesy Matthew Leaycraft.)

**Dr. Larry Gilbert Hall's Home.** According to local nurse Neva Shultis, Dr. Hall charged $2.00 to deliver a baby, $3.00 if there were complications, $2.00 to set a bone, and 12¢ to pull a tooth. Many bills were paid in produce. For example, "a $3.00 bill would be paid with 16 pounds of butter worth $2.50 and four shillings in cash." (Courtesy Kiki Randolf.)

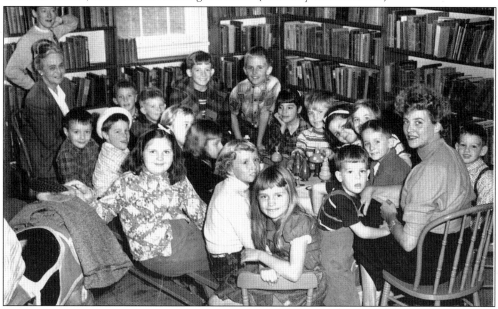

**Students from the Woodstock School Visiting the Library c. 1955.** The children, most of whom are unidentified, are gathered around a table in the Children's Room. You can just see the corner of Spanhankes Merry-Go-Round Steed, painted by the Petershams, which still keeps watch from the corner. The library has adapted to the needs of kids today and has put its focus on Internet technology. (Courtesy Kiki Randolf.)

**THE HARRY RICKS FARM.** The house and barn, just north of Ricks Road on Glasco Turnpike, has been remodeled. Neva Shultis writes that one winter's night, Urving Riseley went to help his neighbor Will Ricks tend a sick horse. Once inside the barn, they heard footsteps outside. Old Marthy Ricks, in a sunbonnet and shawl, appeared enveloped in a blue light. (Courtesy Mike Wholey.)

**DONNA RISELY AND SHERON GRAVER ON THE WALL AT THE NOOK.** This is a great example of the transformations that structures were destined to experience in Woodstock. Originally a barn belonging to George Neher, this structure then became the first home for the Woodstock Book Club. The Nook was first known as a local eatery and ice-cream parlor. Families would sometimes live upstairs and work in the shops below. (Courtesy Sheron Graver.)

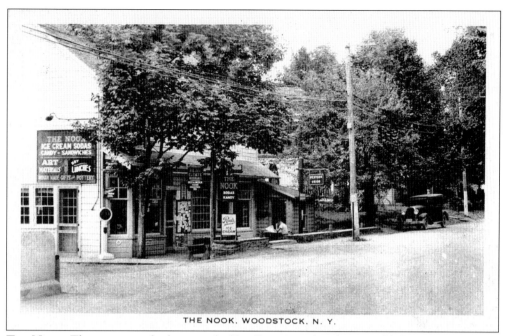

THE NOOK. WOODSTOCK. N. Y.

**THE NOOK.** This was once the location for Hyp Bovee's undertaking establishment and became Café Espresso. On warm summer nights, people could be found sitting at the tables on the popular porch. Whether eating ice cream or listening to the beat of the local bands, this was a popular location for socializing. (Courtesy Irene DeGraff.)

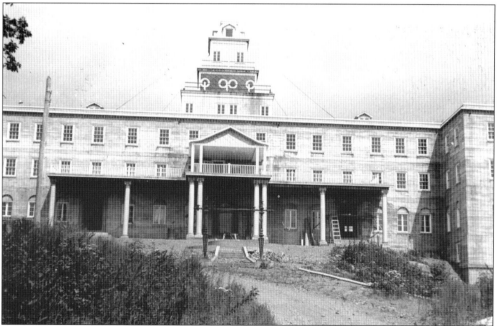

**MORRIS NEWGOLD'S OVERLOOK MOUNTAIN HOUSE.** Alf Evers writes that a massive monolithic concrete structure with a smaller lodge beside it was completed about 1929. It was designed to be like the bungalow colonies of Sullivan County. It was built a few hundred feet south of the burned-out wood frame structure. (Courtesy Bill Baldinger.)

**A DAY HIKE TO OVERLOOK MOUNTAIN HOUSE c. 1930.** Young Ernest Baldinger and his mother Faye bring friends visiting from Great Neck, Long Island, to experience the beauty of the Overlook. The scaffolds are up under the portico, so work is not quite complete. Perhaps the hotel would have fared better if the Overlook Turnpike had been put in. (Courtesy Bill Baldinger.)

**SAM WILSON WITH HIS CHICKENS AT ANDY LEE FIELD.** In December 1938, Clark Neher was president of the Fish and Game Association. The stockholders planned to use donated funds to create a playground to be available to all. They fell into debt and held a square dance contest, the proceeds from which went to cover the $450.00 due to the property owner. (Courtesy Stan Longyear.)

**WOODSTOCK RURAL CARRIER REGGIE LAPO AT RETIREMENT.** Edna Lapo smiles as her husband Reggie receives a citation from postmaster Leon Carey. New rural carrier Joe looks on. Carriers used their own cars and drove an average 50-mile route with 800 rural boxes six days a week. They also processed certified mail and issued 15 to 20 money orders per month on their route. (Courtesy Joe Holdridge.)

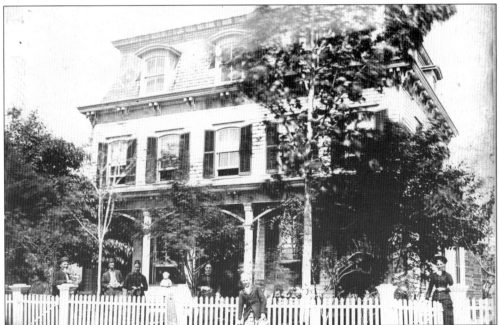

THE STANLEY BRINKERHOFF LONGYEAR HOUSE. In 1768, the Stanley Brinkerhoff Longyear family settled in Little Shandaken, in an area along the Esopus that was once known as Longyear, New York. Alexander Longyear was Woodstock's town clerk and commissioner of highways, and his great-grandson currently holds the commissioner of highway position. (Courtesy Stan Longyear.)

KATHRYN REYNOLDS FOX ON THE LONGYEAR STAGE. Whether a dirt road, a stone road, or a plank road, the journey to Kingston was a long and frequently uncomfortable one. Will Rose writes that his nine-year-old brother drove their aunt Carrie to the West Hurley train station when the stagecoach was not available. (Courtesy Barry Wingert.)

MARION BELL LONGYEAR TENDING THE HOGS. When not working on the family farm in the center of town, Longyear worked for 29 years as secretary to five different principals at the Woodstock Elementary School. During World War II, when meat was scarce, the Longyear family butchered up to 200 pigs a week for the local restaurants to serve for dinners. (Courtesy Stan Longyear.)

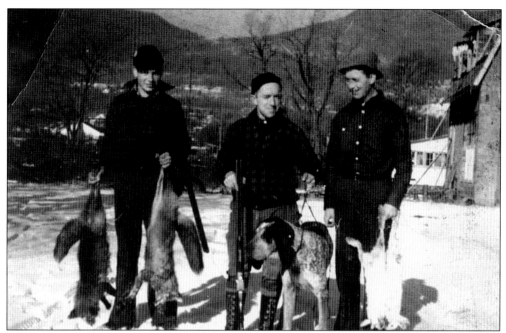

**Showing Off after the Hunt.** Hunting provided a social outlet for local men. In the early 20th century, the fellows seen here behind the Woodstock Hotel on Rock City Road might head to one of the general stores in the village to talk over politics or swap hunting tales. Pictured from left to right are Washy Wilber, Shorty Benjamin, and Ken Wilson. (Courtesy Stan Longyear.)

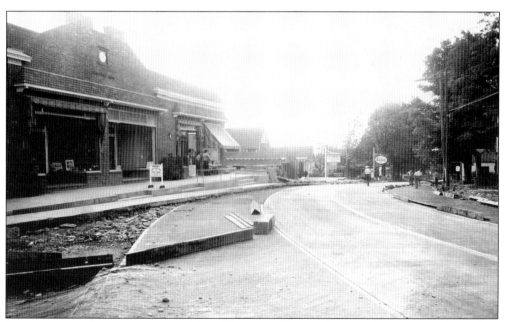

**Repaving the Intersection of Mill Hill and Tinker Street.** Men prepare forms for a section of concrete roadway. Large slabs of local bluestone sidewalk can be seen tipped on end waiting to be reset. The Longyear building has an art shop, and Bill Dixon's Irvington does not have its porch yet. (Courtesy Stan Longyear.)

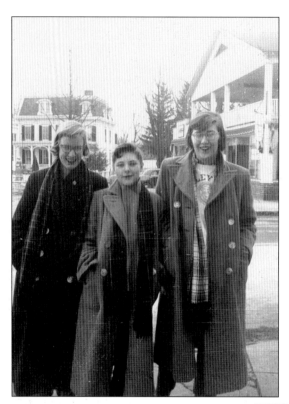

**A Winter Afternoon in Woodstock, 1955.** From left to right, Kari Hastings, Carole Larsen, and Barbara Hastie sport winter coats and scarves as they stand in front of Stowey's. In the background is Edgar Snyder's two-story house, and on the right is the Twaddell House, which was, according to Alf Evers, run in a relaxed way by former drover and horseman Jim Twaddell. (Courtesy Kari Hastings.)

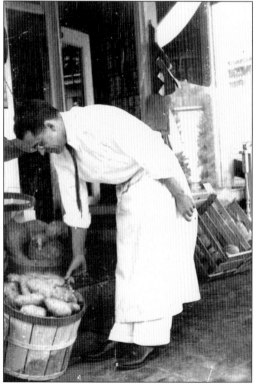

**Fred Mower Selecting Potatoes for a Customer, 1929.** F. B. Happy hired Fred Mower into the business after his marriage to Happy's daughter Catherine. Will Rose writes that 30 years earlier, there was competition between his family's general store and the Elwyn's new store just down the street. (Courtesy Ron Mower.)

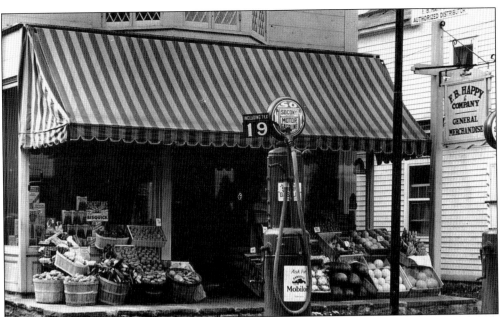

**F. B. HAPPY AND COMPANY, GENERAL MERCHANDISE, 1929.** While the rest of the country was gripping tight as the Great Depression set in, the streets of Woodstock were filled with artists and visitors from around the globe. Many a time, the proprietors would hold a customer's bill through the winter. When the A&P and Grand Union went in, this type of store saw a decline in revenue. (Courtesy Ron Mower.)

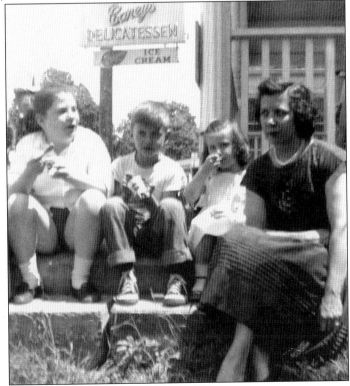

**PLAYING IN FRONT OF LEON CAREY'S DELI.** For most children growing up in the village, the bluestone sidewalks were like their front yards. They knew everyone in the stores by name, and most people lived over their place of business. Pictured here are, from left to right, Pam Dendy, John Mower, Kay Mower, and Anne Mower. (Courtesy John Mower.)

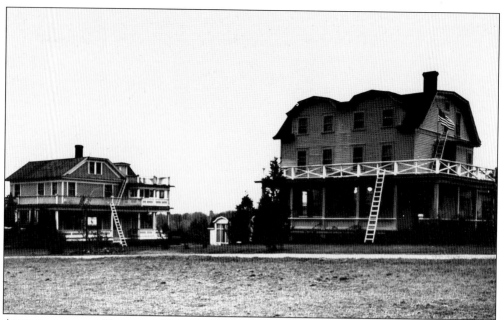

ALLENCREST, THE NATIONAL YOUTH ADMINISTRATION BOYS' RESIDENCE. At one time, this dwelling on the right on Hillcrest Avenue was the residence of artist Willard Allen and is recalled as the hotel where Dyrus and Edith Cook held popular square dances. The Cheats and Swings dance group evolved from these gatherings. In the late 1930s, Bob Elwyn housed his actors and actresses for his summer theater here. (Courtesy Woodstock Library.)

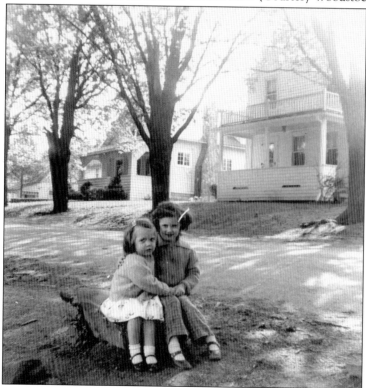

A 1950s VIEW FROM MOWER'S FIELD. Maple Lane was once a quiet, tree-lined street with well-kept homes and open, airy lawns. Here sisters Linda and Kay Mower take time out from play to pose for a picture. (Courtesy Anne Mower.)

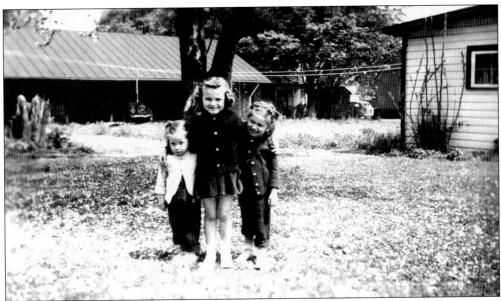

**PATTY MOWER, MARILYN WOLVEN, AND BARBARA MOWER, 1948.** To the right of the Christ's Luthern Church's sheds is the house that was at one time occupied by artist Bartow Matteson. It was built by Norvin Lasher when he started an undertaking business. One of the outbuildings was used as a funeral parlor. Norvin Lasher later sold the business to his cousin Victor Lasher. (Courtesy Anne Mower.)

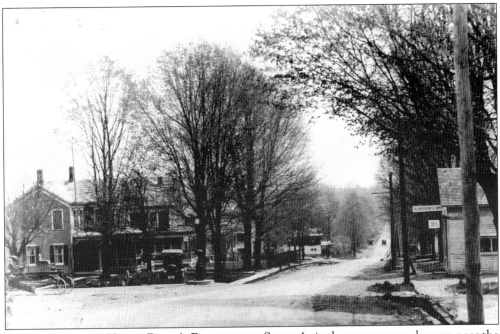

**LOOKING TOWARD HENRY PEPER'S BLACKSMITH SHOP.** A single gas pump can be seen near the corner of Florence Peper's house. Allen Electric advertises radio supplies. There is a street lamp in front of Dave Myer's house and quite a dip in the road just before the Woodstock Garage. Farther down is a two-story house with a tree-lined front yard. (Courtesy Dominique Vos.)

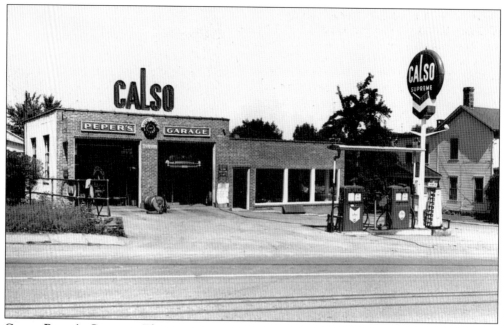

**CALSO-PEPER'S GARAGE.** This was once the site of Henry Peper's blacksmith shop. With no need to shoe horses for transportation, residents and travelers managed just fine with the choice of two gas stations in the village. Alf Evers writes that Hervey White nursed Henry Peper's son Will during the 1918 flu epidemic. (Courtesy Kiki Randolf.)

**WATER FLOWING ON A BRIGHT SUMMER DAY.** Pictured here are, from left to right, Bill Heckeroth, Peter Cooper, and Joyce Stowell. Joyce's father, Stowey, was a professional photographer and took this shot while the children were playing in their front yard on Millstream Road. As the population grew in Woodstock, the town board and health department saw the need for safe public drinking water and created a water district. (Courtesy Bill Heckeroth.)

**BATHING IN THE SAWKILL NEAR ABRAM WILBER'S SAWMILL.** A report issued in 1925 by the Kingston Water Department expressed concern about houses near the Sawkill being served by outdoor privies. They also noted an increase in campers along the stream and were concerned about disposal of foodstuffs and bodily waste into the water supply. Sanitary patrol personnel monitored the areas of concern. (Courtesy Kingston Water Department.)

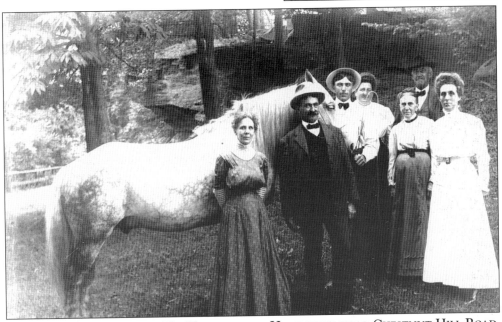

**NORVIN LASHER STEADYING HIS HORSE AT THE HOMESTEAD NEAR CHESTNUT HILL ROAD.** A stonecutter by trade, Lasher lost upwards of $70,000 in the early 1920s as his quarry business fell off. His mother stands to his right, with the black waistband and collar, and behind her is his father, Alva Lasher. All others are unidentified. In the background, the dirt road leads from Woodstock to Saugerties. (Courtesy Dave Jeffery.)

THE LIVING ROOM INSIDE CARL LINDEN'S MILL HOUSE c. 1925. The 1920s were an exciting time in Woodstock. People with art and literary backgrounds mingled with stockbrokers, accountants, and local business families. People from this intellectual mix would soon create the historical society, the Woodstock Country Club, and the Woodstock Library. (Courtesy Matthew Leaycraft.)

THE MILL WHEEL AND MILL RACE ALONG THE SAWKILL. This site is believed to be the location of a mill during the Livingston era. Will Rose writes about a herd of Aaron Riseley's cows that were caught out in the fields south of the mill during a severe thunderstorm. Brook Romer was walking back from West Hurley and saw 13 cows get struck at once. (Courtesy Matthew Leaycraft.)

PETER LEAYCRAFT PLAYING IN FRONT OF THE MILL c. 1925. When Woodstock Property Inc. gained ownership of this site from Carl Linden, the members went to work moving buildings around to accommodate the social needs of the club. Features included a private bar, tennis courts, and swimming in the Sawkill. (Courtesy Matthew Leaycraft.)

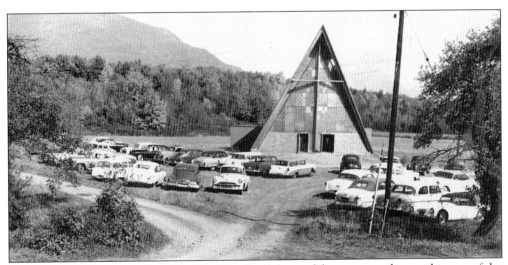

THE A-FRAME CHURCH. In 1954, Alice Wardwell donated four acres to the parishioners of the "corn crib" church to build a larger house of worship. The first advisory committee included Goodwin Cowles, James Hood, Fennel Franckling, Lamont Marvin, Houston Richards, and Alan Styles. Their first full-time priest, Father Lloyd Uyeki of Poughkeepsie, was hired in 1959. Recent renovations have removed the stain glass windows. (Courtesy Kiki Randolf.)

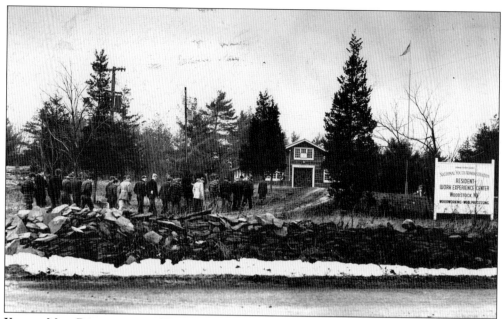

YOUNG MEN PREPARING TO WORK AT THE NATIONAL YOUTH ADMINISTRATION FACILITY.
The campus included three shops, a barn built in 1900, and other outbuildings. The main
focus was training in industrial arts occupations, which included woodworking, stonecutting,
and metal work. Students were given room and board as well as a stipend during their stay in
Woodstock. (Courtesy Woodstock Library.)

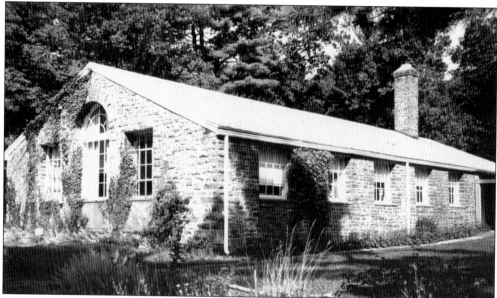

THE NATIONAL YOUTH ADMINISTRATION WOODSTOCK SCHOOL OF ART HISTORIC SITE.
This building was constructed by the residents around 1938 under the guidance of local artisans
such as Tom Penning. The planning committee was headed by Norman T. Boggs, and the design
of the building is attributed to Kingston resident Edmund Cloonan. The training program was
designed to foster a philosophy of independence and self-reliance in disadvantaged youth.
(Courtesy Kingston Water Department.)

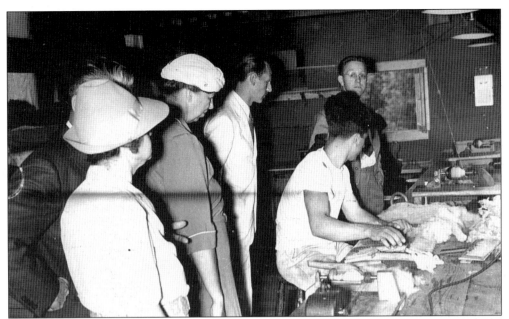

ELEANOR ROOSEVELT AND OTHERS INSPECTING A RUG. Young men and women from around the state were brought to Woodstock for the National Youth Administration program. The first lady considered this program to be vitally important to the future of the country. When the United States entered into World War II, the program lost its federal support. (Courtesy Woodstock Library.)

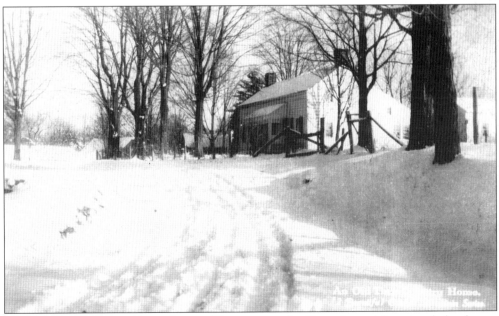

THE SHUFELT HOUSE, ZENA ROAD. The primary dwelling, the red barn, and the former Hardenberg gristmill complex were occupied by the Charles Shufelt family during the 19th and 20th centuries. As the family grew, the two houses on either side of the main house were built. (Courtesy Fern Malkine.)

**THE GIRLS' RESIDENCE FOR THE NATIONAL YOUTH ADMINISTRATION.** The stone house on the south side of Baumgarten Road was the residence for girls in the National Youth Administration. According to Alf Evers, in May 1760, Gerrit Newkerk bought land from the Johannis Hardenbergh heirs and constructed this fine stone building. (Courtesy Woodstock Library.)

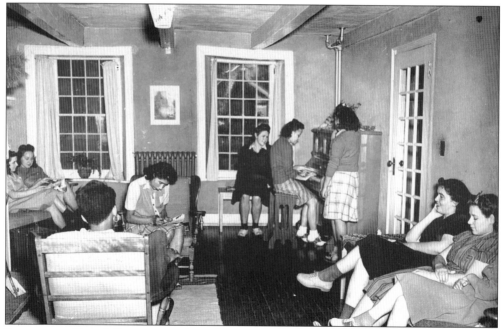

**INSIDE THE GIRLS' RESIDENCE.** According to the application for National Historic Places, Eleanor Roosevelt sponsored a home craft industry. Also, wool processed at the Woodstock camp was purchased for use by Val Kill weaver Nellie Johanssen. The first lady would invite the students to her residence to swim and picnic. (Courtesy Woodstock Library.)

THE ELLIS WOLVEN–GITNICK HOMESTEAD. Fertile farmland and bluestone quarries attracted Cornelis Van Keuren to this site around 1745. Ellis Wolven built this fine wood frame house around 1884. Later Albert Cashdollar used the property to quarry stone for local road rebuilding. (Courtesy Francesca Husted.)

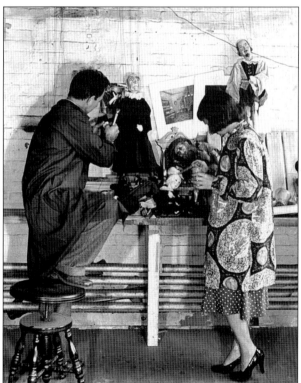

FLORENCE AND STEPHEN GITNICK AND THE BERKELEY MARIONETTES. The world-renowned Gitnicks purchased the run-down Wolven dwelling from road superintendent Albert Cashdoller in 1950. They planned to use the barn on the property to rehearse their plays. A delay occurred when they discovered Asa Yeaple had stored a large amount of dynamite in the barn. (Courtesy Francesca Husted.)

91

**Janine Fallon on the Bluestone Patio at the Shufelt-Fallon House, 1956.** The farmhouse has a large fireplace, two summer porches, a cellar once stocked with home canned goods, two stairways, and thirteen rooms. Once part of a larger farm holding, the backyard was large enough for neighborhood kickball and baseball games. Maple, apple, and catalpa trees lined the property along Zena Road. (Author's collection.)

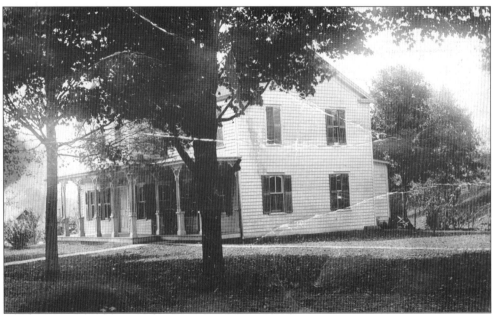

SHUFELT-FALLON HOUSE. Located on Zena Road's sharp turn past the red barn, the house is said to be the site of the Zena post office in the early 1900s. Rick Danko rented this house, and the Band would rehearse in one of the upstairs bedrooms. With the influx of IBM workers, most of the fields were sold to create the early Zena housing development. (Courtesy Ginny Pettit.)

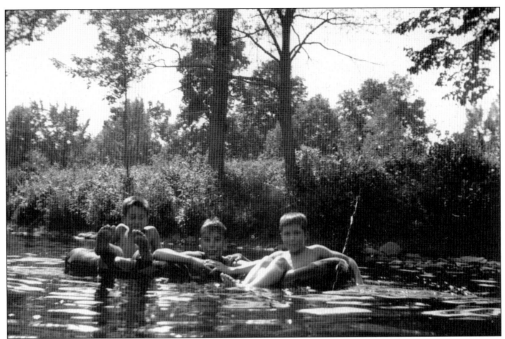

**JOHN MELLERT AND FRIENDS TUBING THE SAWKILL.** Once the spring runoff has abated, the Sawkill reveals its little pools and ponds quietly waiting to be enjoyed. With patience, little brook trout could be caught in the stream. In the spring, one might see a nest of frog's eggs or a gang of pollywogs. (Courtesy Gayle Mellert Donoghue.)

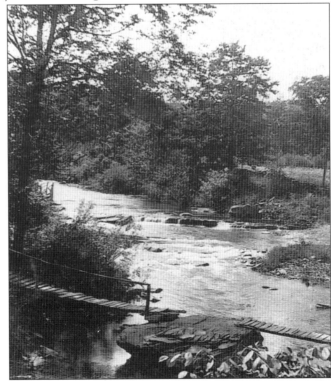

**FOOT BRIDGE TO THE MELLERT FARM.** At one time, this bridge in Allencrest was the only access to this farm from the Zena Sawkill Road. Access for the Mellert-Kidd family was via the John Joy Road past the Klementis farm. Modern-day roads often follow the same course that the roads of 100 years ago did, but this is not always the case. (Courtesy Gayle Mellert Donoghue.)

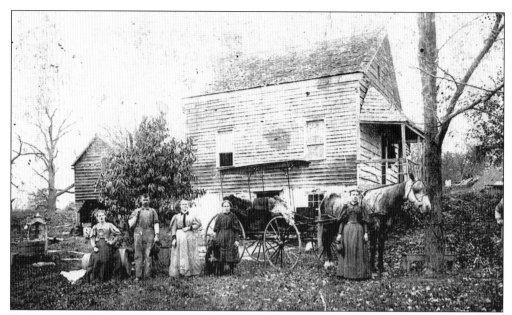

**THE MELLERT-KIDD FARM IN ZENA.** It is not known how the Kidd family came to Zena, but David Kidd carved his name into the large rock in the middle of the Sawkill stream near his homestead. Mary Kidd married William Mellert, and they raised their family on the farm. (Courtesy Gayle Mellert Donoghue.)

**GAYLE MELLERT PLAYING IN THE FIELDS.** The Mellert family farm was self-sufficient. Fields were planted with corn and hay, and an apple orchard surrounded the house. The workhorse coexisted with pigs, cows, chickens, and ducks. The children fished in the stream. Their father Dave cut and hauled wood to supply fuel for heating and cooking. (Courtesy Gayle Mellert Donoghue.)

**SUMMER BOARDERS WITH MELLERT CHILDREN.** When the summer season arrived, the children set up tents and camped in the backyard. Empty bedrooms became summer housing for artists from the Art Students' League. The fee of $1.50 a day included board with a hearty farm breakfast cooked by Mary Abood Mellert. Gayle is kneeling in front on the right with Laura Vogel just behind her. (Courtesy Gayle Mellert Donoghue.)

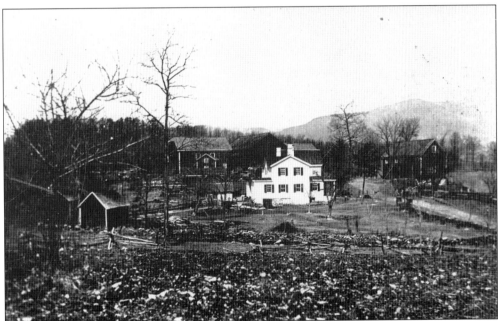

THE VANDEBOGART OF ZENA FARM COMPLEX. Also referred to as the VanEtten farm, this large land holding was in the area of the intersection of VanDeBogart and VanDale Roads. The 1820 federal census reports a Peter VanDeBogart and a Peter Van Etten living near each other in the "Anguagekink" area. (Courtesy Historical Society of Woodstock.)

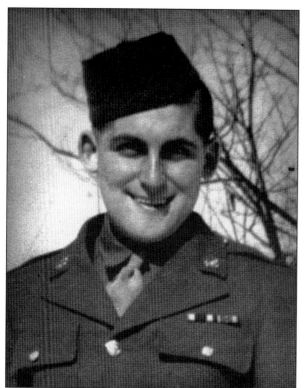

**JOHN HOLUMZER.** John Holumzer's parents, Aurel Holumzer and Marie Klementisz, entered the United States through Ellis Island. On some census records, they gave their county of origin as Austro-German and on others as Hungary. Could it be possible that the origin of the hamlet Zena's name is taken from this Hungarian heritage? The Hungarians have a term, *Wodna Zena,* which means "water woman." (Courtesy Historical Society of Woodstock.)

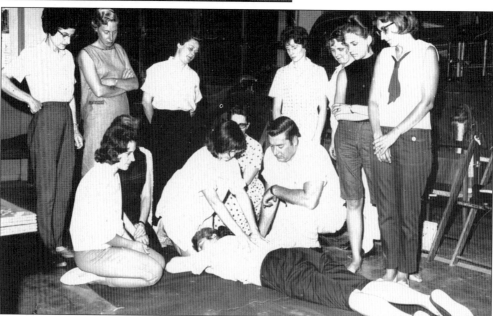

**LEARNING TO PERFORM CPR AT THE ZENA FIREHOUSE.** Members of the Ladies Auxiliary are taught CPR by Gil Gray, who owned a private ambulance company. The five members in the front are unidentified. Pictured in the back row are, from left to right, as follows: Gerri May, Vera Klein, Louise MacCloud, unidentifed, Evelyn Wolven, Linda Thaisz, and Marge Guerin. (Courtesy Helen Mayer.)

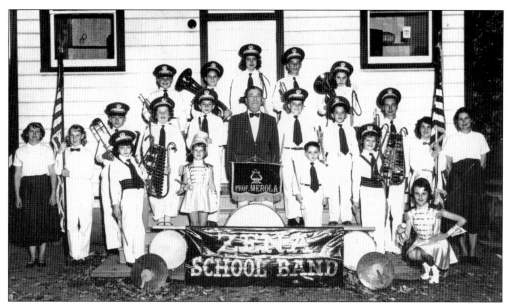

THE ZENA SCHOOL BAND. Band members are preparing for a trip to New York City. Pictured here are, from left to right, as follows: (front row) Helen Mayer, unknown, Bonnie Wiltise, Julie Holumzer, Professor Merola, David Holumzer, ? Hung, and Marilyn Wolven; (middle row) John Holumzer, ? Casey, Al Holumzer, Richie Mellert, Stewart DeWitt, Alice ?, and Edna DeWitt; (back row) John Joy, ? VanKleeck, Carol DeWitt, Herbie Vogel, and unidentified. (Courtesy Helen Mayer.)

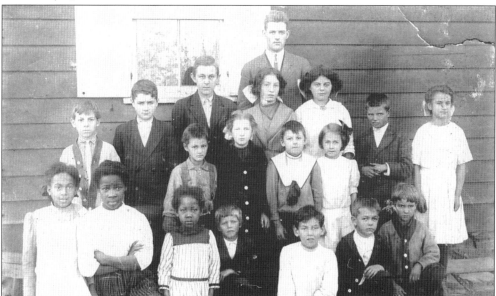

ZENA SCHOOL, 1913. Among the students pictured are Dave Mellert (front row, third from the right), Harold Carl (second row, far left), Clifford Carnwright (standing next to Carl), Carrie Carnright (second row, third from right), Nellie Carnright (second row, far right), Margaurite Snyder (third row, far right). The names of all the other children in this image are unknown. The 1910 federal census indicates that the Kidd, Long, and DuBois families were living near the school, and the children of these families could have been attending here. (Courtesy Gayle Mellert Donoghue.)

FOUNDING MEMBERS OF THE ZENA FIRE COMPANY No. 4 AUXILIARY. Pictured here are, from left to right, as follows: (front row, seated) Mary Mellert, Louisa Thaisz, Laura Vogel, and May Hung; (second row) Helen Mayer, ? Wiltsie, Ginny Hoffman, Ruth Holumzer, Vera Klein, Evelyn Wolven, Mabel Hung, and Evie Taylor. The women raised funds to purchase appliances and gear for the firemen. (Courtesy Helen Mayer.)

HIBYAN'S STORE AT THE ZENA FOUR CORNERS. Louis Hibyan and his wife, "Tante" Kacska Hibyan, moved from Brooklyn to Zena c. 1910. Tante, weary of traveling to Catskill for tasty bread, began to bake her own and sold loaves to neighbors. She suggested that Louis build her a store so that she could bake more bread and increase her sales. He built her a store in 1913. (Courtesy Ellie Thaisz.)

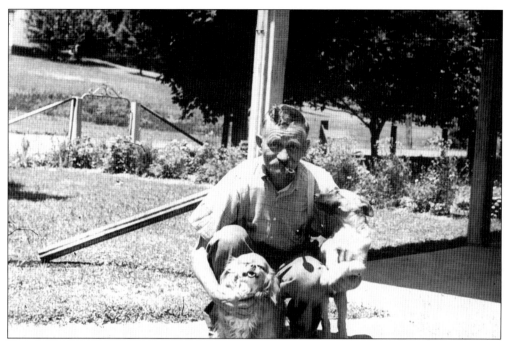

**LOUIS HIBYAN WITH RUDY AND SHEENA, JULY 1939.** The land on which Louis built the store was once part of the Carnright farm. Federal census evidence suggests that the Hibyan, Klementis, Holumzer, and Baldinger families lived near each other in Brooklyn. The Baldinger and Klementis families were neighbors there in 1910. (Courtesy Ellie Thaisz.)

**FRED THAISZ IN HIBYAN'S FRONT YARD, JULY 1938.** Fred Thaisz's mother, Louisa, and Tante Hibyan were sisters. The church building is in the background, and the cemetery would be to the left. Peter Leaycraft writes that this area was largely settled by the Van Etten family, and one headstone tells us Guyabert Van Etten was buried in 1807. (Courtesy Ellie Thaisz.)

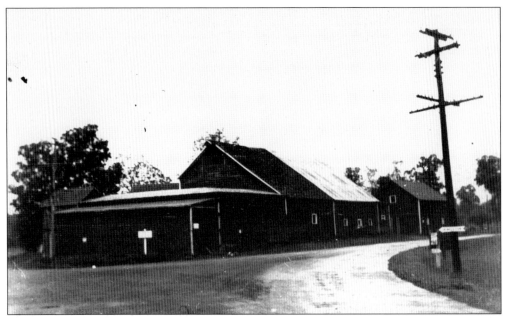

THE CARNRIGHT-ROWE BARNS AT THE ZENA CROSSROADS. Seven Revolutionary and four Civil War veterans are interred in the cemetery across the street from the barns. Locals recall evidence of a dirt road that passed between the large barns and the Carnright-Rowe house. The Carnrights would later marry into the Shufelt family and move up Zena Road toward town. (Courtesy Ellie Thaisz.)

CLIFFORD CARNRIGHT POSES ON THE FAMILY FARM IN ZENA, JANUARY 1918. Like many local men, Cliff went to work for the Kingston Water Department. He would eventually transfer to the Reservoir No. 3 superintendent's house in Lake Hill. Each reservoir required an on-site supervisor, on-call day or night. They had gates and water screens to manage, leaks to watch for, and trespassers to turn away. (Courtesy Ginny Pettit.)

**KINGSTON WATER SUPPLY RESERVOIR NO. 1.** Land surrounding this body of water was once owned by William Winne. The Kingston Water Department purchased it from William Joy in 1885, and it was the site of a snuff mill pond. Many years ago, kids growing up in Zena ice-skated on the reservoir in the winter and occasionally a bonfire was set on the shore. (Courtesy Kingston Water Department.)

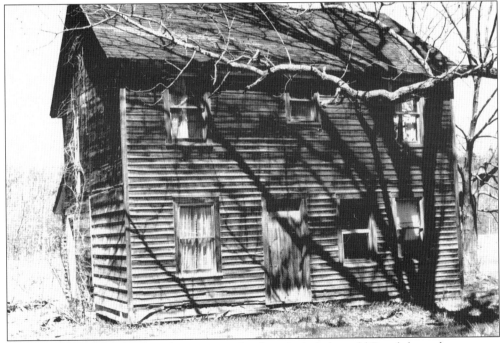

**THE PETER JOY FARMHOUSE.** At one time, this farm included an old Dutch barn that sat near the road and a carriage house. The family plowed the rich soil in fields along the Sawkill in an area they called "the island." (Courtesy Phil Naccarato.)

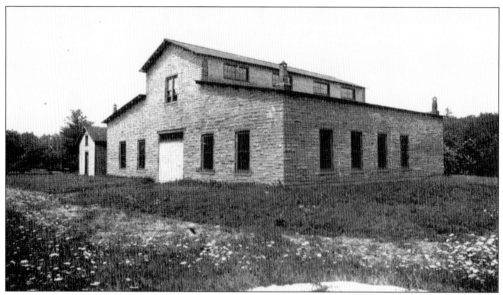

THE EDMUND T. CLOONAN WATER TREATMENT PLANT. Built in 1897, the building is an American Water Works Association National Landmark. It is believed that Cloonan patterned the National Youth Administration (NYA) building after this structure. Land in this area was once owned by William Winne. (Courtesy Kingston Water Department.)

WALKING HOME FROM THE JOY FARM c. 1940. From left to right, Bob Wolven, Bill Baldinger, and Charlie Wolven dawdle along down the middle of Zena Road. The boys were occasionally sent to collect fresh cows' milk in pails to bring home for a meal. With very little car traffic to contend with, the boys were safe to amble along at their own speed. (Courtesy Bill Baldinger.)

*Four*

# PARADES, POLITICS, AND PEOPLE

**APPROACHING TOWN FROM THE WOODSTOCK WEST HURLEY ROAD.** An advertising billboard for the Woodstock Playhouse, featuring Elisa Landi, has been placed just before Witch Tree Road and the old Russell farm. This is the view that local servicemen returning from World War II savored—the mountains looming high above their hometown, a sign that they were home. (Courtesy Irene Shultis DeGraff.)

**WOODSTOCK VILLAGE SQUARE, JUNE 1938.** What's different in this picture? A single streetlight hangs in the center of the roadway, with the post office in the background and the store on the corner. Placing a streetlight at a busy intersection is a natural progression from an increase in car traffic. This quiet country village begins its change to a busy art colony and tourist attraction. (Courtesy Ellie Thaisz.)

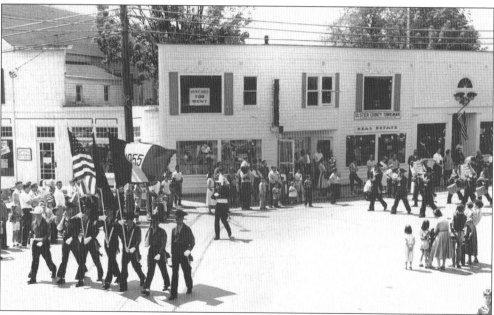

**THE SAME CORNER, TEN YEARS LATER.** As the parade winds its way up to the cemetery, onlookers stand in the central shopping area of the village. The arrival of the family car brought with it the ability to take day trips and weekend getaways. The increase in activity and value of commercial property prompted many homeowners in the village to sell, and the buildings became storefronts instead of homes. (Courtesy Kiki Randolf.)

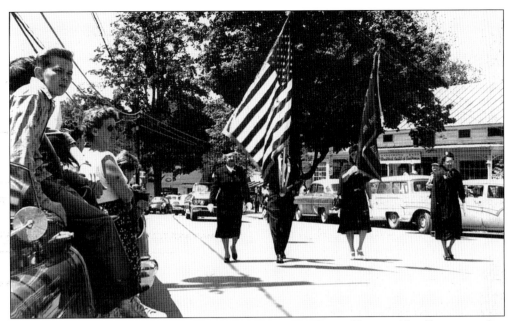

**LEGION POST 1026 AUXILIARY PASSING THE OLD ISAAC DAVIS HOUSE.** Alex Sharpe watches as two unidentified women march with Velma Cashdollar Grazier (second from right) and her mother Walena Cashdollar (far right). The Davis property included the Tannery Brook falls site across the street. According to Alf Evers, this 107-acre site was sold to Davis by Chancellor Livingston in 1789. (Courtesy Sheron Graver.)

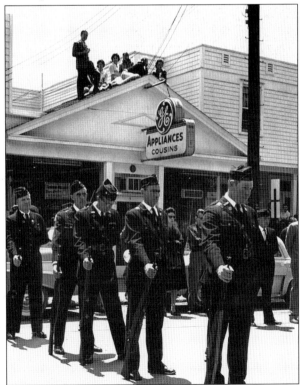

**MEMBERS OF LEGION POST 1026 AT PARADE REST.** Pictured here are, from left to right, unidentified, Lester Avery, unidentified, Eric Wiltz, and Don Adams. The best view of the ceremony was atop the Cousins appliance store. The post, founded in March 1930, honors all fallen service people with an annual parade, a dedication service, and fellowship. (Courtesy Sheron Graver.)

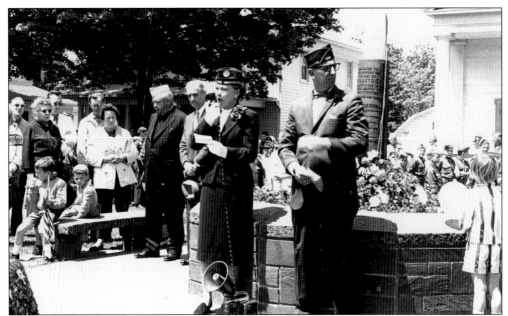

**VELMA CASHDOLLAR GRAZIER AT THE WAR MEMORIAL ON THE VILLAGE GREEN.** Woodstockers of the World War II generation were quite passionate about their support of the national government. Some of the local unrest in the 1960s has been attributed to the clash between these same World War II citizens and the newcomers, who were Vietnam War protesters. (Courtesy Sheron Graver.)

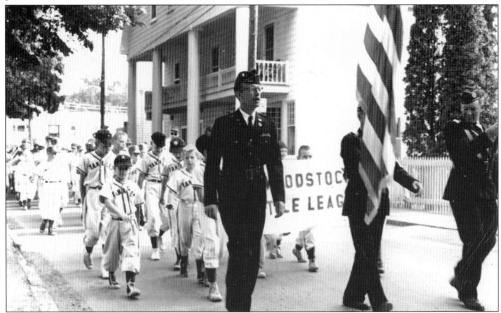

**WOODSTOCK LITTLE LEAGUE ESCORTED BY HONOR GUARD.** The people marching in this parade are unidentified except for Sonny Longyear on the far right. Sonny, a descendant of the Longyears of Little Shandaken, grew up in Woodstock and played baseball before serving in World War II. Little League has been an annual rite of passage for many young Woodstockers. (Courtesy Kiki Randolf.)

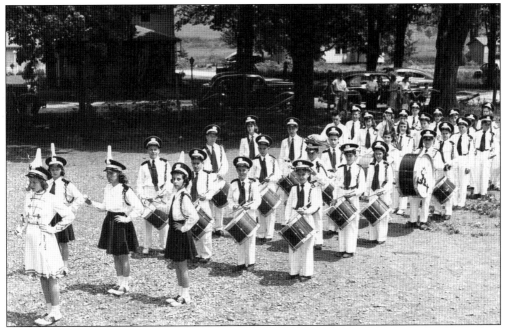

THE WOODSTOCK SCHOOL BAND. Students line up in full uniform, ready to entertain their family and friends in the parade. Nowadays, the Onteora School band performs for two other communities before arriving in Woodstock for the noon start. Note the tree-lined Mill Hill Road and Elwyn Lane area in the background. (Courtesy Bill Heckeroth.)

MEMORIAL DAY PARADE FLOAT, 1985. Ladies Auxiliary Fire Company No. 1 member Dodie Maclary Reynolds portrays the part of a wounded soldier in the "MASH" unit. The Auxiliary was founded in 1930 and holds annual penny socials and bake sales at the new firehouse on Route 212 in Bearsville. The proceeds of these fundraisers help support the members of Fire Company No. 1 and their equipment needs. (Author's collection.)

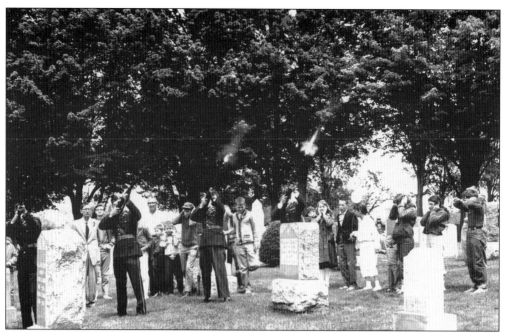

**THE 21-GUN SALUTE.** Most parade observers make their way from the center of town to the cemetery as the parade winds down. The war memorial has been moved to this site after spending years on the village green. Young children hold their ears as the blanks are shot off. Old men shudder with the memories of combat. (Courtesy Sheron Graver.)

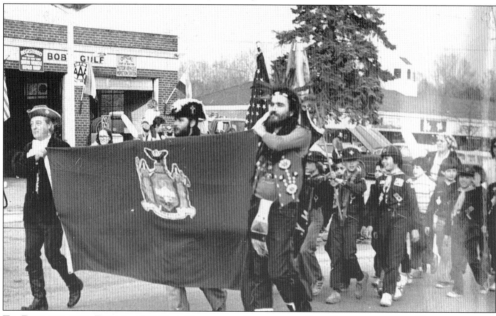

**ED BALMER AND ROBERT DE PEW REYNOLDS LEAD THE CUB SCOUTS IN THE BICENTENNIAL PARADE.** Ed Balmer was a welcome site on the village green each fall, demonstrating how to press apples. Robert De Pew Reynolds brought the community a sense of Native American culture and peaceful protest. In the background is Bob Croissant's Gulf Station. Town planners disallowed a car wash at this site, prompting Croissant's entry into local politics. (Courtesy Kiki Randolf.)

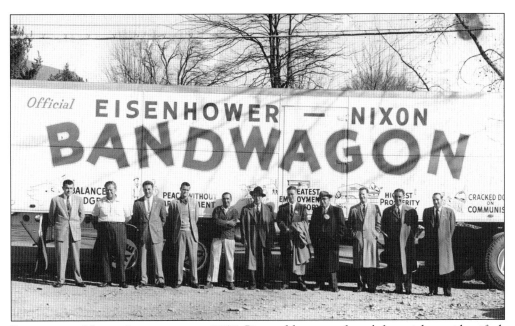

**EISENHOWER-NIXON SUPPORTERS c. 1956.** Pictured here are, from left to right, unidentified, Lew Wilson, Jim Kinns, Bill Waterous, Joe Reayela, Kermit Schwarz, Ken Wilson, Tony DeLisio, Buzzy Fitzsimmons, Joe Forno, and Fred Tripico. Local Republicans were active in all aspect of Woodstocks business and social circles. How different it is today! (Courtesy Kiki Randolf.)

**POSING WITH GOVERNOR ROCKEFELLER.** Pictured here are, from left to right, Marion Callaghan Umhey, Gov. Nelson Rockefeller, Kiki Randolf, assemblyman Ken Wilson, and unidentified. Randolf, a staunch Democrat, and Umhey, a dyed-in-the-wool Republican, were successful business partners for many years. They ran the Ulster County Townsman and were both outspoken on many local issues. Their formula was to support the person, not the party. (Courtesy Kiki Randolf.)

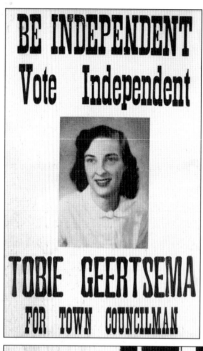

**BEING INDEPENDENT, NOVEMBER 6, 1957.** This feisty mother of twin girls, registered as a Republican in a Republican town, and ran on the Democratic and Independent ticket. Part of her platform was the centralization of the Onteora School District. She defeated two-term Republican Herb Keefe by 100 votes. Almost 15 years passed before another woman took a seat on the town board. (Courtesy Tobie Gertseema.)

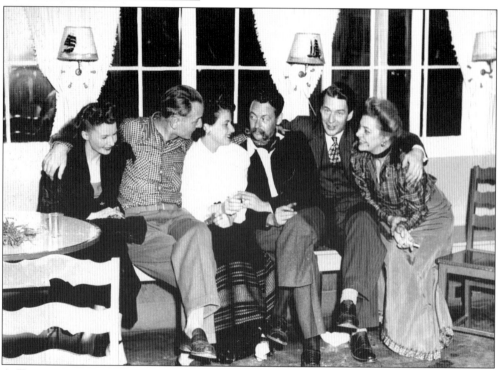

**A THEATER PARTY AT THE SEAHORSE.** From left to right, Maggie Moore, Bill Tuck, Fritzie Striebel, John Pike, ? Reed, and Clemmie Nessel share a moment on opening night for the Foundation play *Gold in the Hills*. Woodstockers spent many nights barhopping around the village. During this era, politicians, artists, locals, natives, and the occasional visitor from a neighboring town interacted in the bars. (Courtesy Woodstock Library.)

**MARY CONICK, PAULA PERLMAN, AND POOKIE GODWIN OUTSIDE TOWN HALL.** The multipurpose town hall building continues to serve as a polling place for voters. At one time, Dave Myers rented the town hall and ran a movie on weekends. He hired local teenagers to work the projectors. Dave made sure he was at the door, collecting the price of admission. (Courtesy Kiki Randolf.)

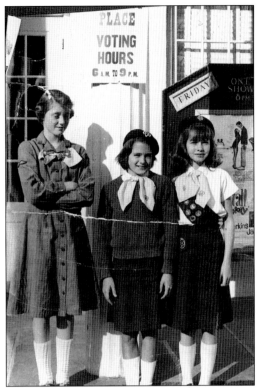

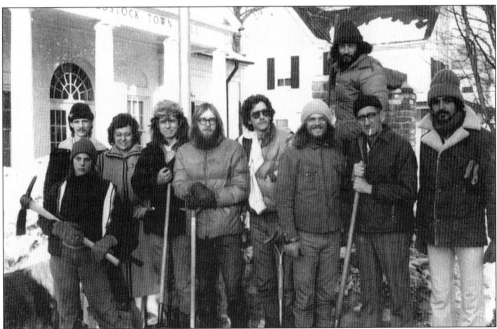

**SUPERVISOR VAL CADDEN AND CETA WORK CREW.** Val Cadden has the distinction of being the first woman to be elected supervisor in the town of Woodstock. Val entered into politics during the IBM era of the 1970s and is regarded as a hands-on, well-respected leader. (Courtesy Kiki Randolf.)

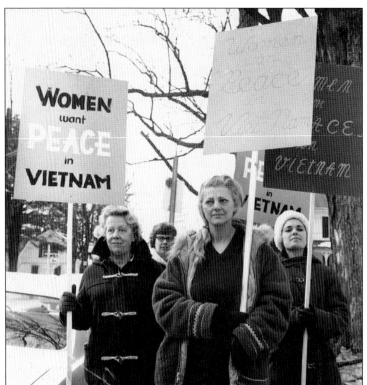

**PROTESTING ON THE STREETS OF WOODSTOCK.** Though the women holding the placards are unidentified, the message is loud and clear. The community has evolved to tolerate social and political protests better than it did in the "good old days." Other communities say Woodstock carries protesting a little too far. Most people living within town borders support an individual's right to freedom of speech. (Courtesy Kiki Randolf.)

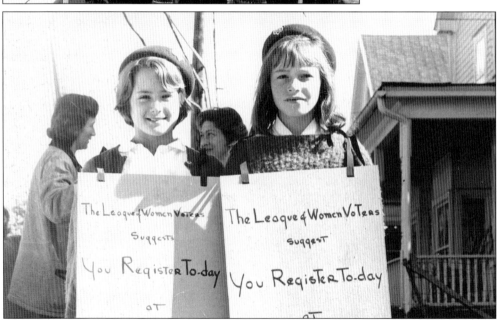

**POOKIE GODWIN AND PAULA PEARLMAN SUPPORTING THE LEAGUE OF WOMEN VOTERS.** Kiki Randolf, Betty Schwarz, and other politically active Woodstock women formed a chapter of the League of Women Voters here in town. Today if a tough debate is expected during local campaign time, League of Women Voters members from Kingston are called upon to moderate the candidate's night. (Courtesy Kiki Randolf.)

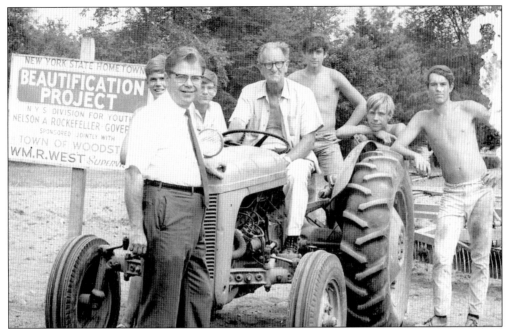

**SUPERVISOR BILL WEST OVERSEEING THE BEAUTIFICATION PROJECT.** The Town of Woodstock came into possession of the property now known as Andy Lee Field through a process known as adverse possession. Monroe Longendyke sits on the tractor surrounded by members of the division for youth. They are preparing to clean up the property. (Courtesy Kiki Randolf.)

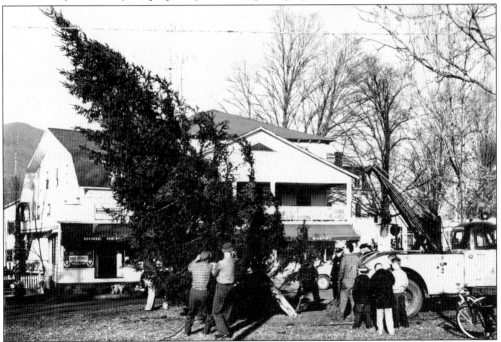

**PUTTING UP THE CHRISTMAS TREE ON THE VILLAGE GREEN.** Local men hoist the freshly cut tree into place. This process has changed significantly. Now the programs are high tech, and a small tree is planted and decorated with little white lights. (Courtesy Kiki Randolf.)

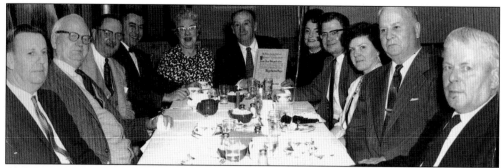

**A CHRISTMAS EVE COMMITTEE.** For over 70 years, volunteers have planned Woodstock's Christmas Eve program. Members of the community receive food baskets and holiday cheer baskets sponsored by the Christmas Eve Committee. Pictured here are, from left to right, Milt Combs, Frank Benson, George Eichler, unidentified, Nora Holdridge, Joe Holdridge Sr., Kiki Randolf, Bill West, Ruth Shultis Kinns, ? Benson, and unidentified. (Courtesy Kiki Randolf.)

**SANTA FLOATING DOWN FROM THE STEEPLE.** Many Woodstockers recall when Joe Holdridge Sr. climbed out of the trapdoor and carefully prepared to slide down the cable to the village green. Holdridge was a dedicated Santa and gave of his time to the children of Woodstock for over 30 years. (Courtesy Kiki Randolf.)

**REFORMED CHURCH SUMMER FAIR.** The green has always been a gathering place for people who live in Woodstock or who are just visiting. Before skateboarders and hippies, the green attracted beatniks, artists, and musicians. Most natives do not consider the green a place to hang out, in part out of respect for the placement of the war memorial and monument. (Courtesy Kiki Randolf.)

**ANY PROBLEM UNDER THE SUN.** Family of Woodstock was created in 1969–1970 as a direct result of the Woodstock 1969 Music Festival. Though locals resented this helping group of people and blamed its presence in the center of town for the continued traffic of a great mass of unwashed and unwanted drifters, Family of Woodstock is an organization that has blossomed to serve multiple communities. (Courtesy Kiki Randolf.)

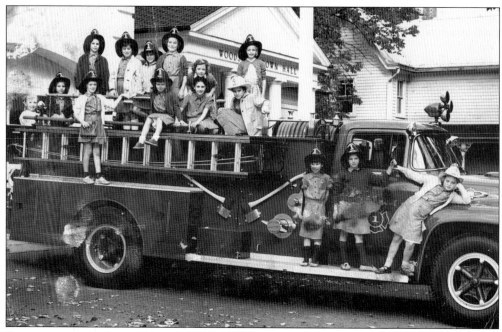

**Brownies on the Fire Company No. 1 Truck.** At one time, most of the buildings in town were built of wood and heated by wood or coal stoves. Company No. 1 was formed in 1906 after a series of large buildings in the center of town burned due to lack of access to water and equipment. The girls are all members of the local Brownie troop. (Courtesy Kiki Randolf.)

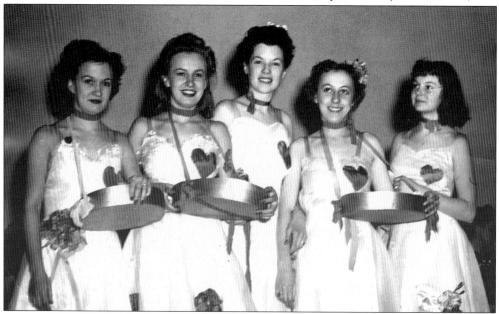

**Raising Funds for the War Effort.** Pictured here, from left to right, are Ruth Houst Kelly, June Kelly, Edith Heckeroth, and two unidentified young women. Local people were quick to raise funds for many different nations suffering during World War II. There was even an event called the Nine Nations Fete in September 1943. Street booths were planned around the green, and locals sold items representing different countries. (Courtesy Bill Heckeroth.)

**SHARING THEIR HERITAGE.** Mona Jore (left) and Randi Singsaas attend a Russian War Relief event. Anita Smith writes that a branch of the Russian War Relief was formed in Woodstock with a Mrs. Vladimir Padwa as chairwoman. Activities such as Christmas parties at private residences, basket picnics with local artists, and noted speakers sponsored at town hall were held to raise funds for Russian war refugees. (Courtesy Kari Singsaas Hastings.)

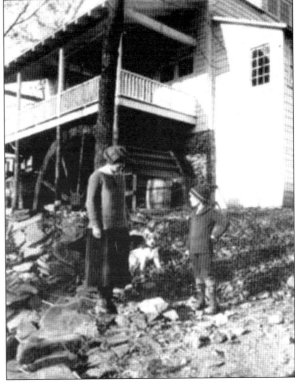

**ANITA SMITH VISITING WITH PETER LEAYCRAFT.** Anita Smith, an artist, local historian, and writer, must have influenced Peter Leaycraft, as he later became one of the town historians. During World War II, Smith was appointed chief observer for the U.S. Army-Air Force in Woodstock. An observation post was built at Rock City Corners, and many volunteered their time to watch for enemy planes. (Courtesy Matthew Leaycraft.)

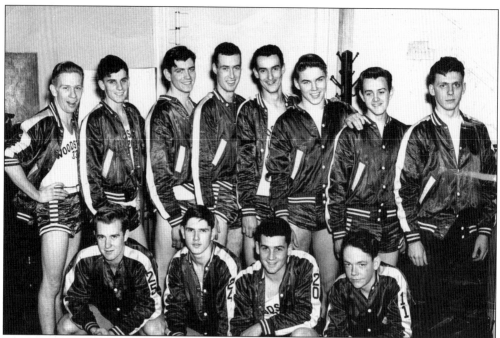

**THE WOODSTOCK V'S c. 1950.** The Woodstock V's were comprised of young men, many of them World War II veterans, who loved to play basketball. Pictured here are, from left to right, as follows: (front row) Don West, Gene Snyder, Barry Neher, and Paul Van Wagenen; (back row) Joe Holdridge, Andre Neher, Bill Kleine, Art Somers, Ken Harder, Sam Wilson, Bill Waterous, and assistant coach Grant Gavin. The games were played at town hall. Competing teams came from surrounding communities. (Courtesy Joe Holdridge.)

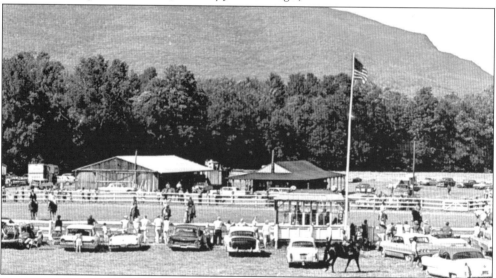

**THE WOODSTOCK RIDING CLUB.** The Woodstock Riding Club was founded in 1947 by local horse lovers; their first horseshow was that June in Lake Hill. Seven hundred people attended to watch 30 contestants compete in western-style riding. They purchased the 19-acre property on Broadview from the Victor Cannon family in 1949. Founding members included Virgil and Louise Van Wagonen, Ned Chase, Paul Perlman, Winsley Muller, and Ada Herrick. (Author's collection.)

**LILLIAN AND MORTIMER DOWNER, DRESSED FOR THE MAVERICK FESTIVAL.** The Downer family arrived in Woodstock in 1898 and immediately became an integral part of the community. Dr. Mortimer Downer never refused a sick call, traveling in his horse-drawn buggy day or night, any distance. As hospitals were difficult to get to, he performed operations at people's homes, using ether to anesthetize the patient. (Courtesy Downer family.)

**GALE BROWNLEE PORTRAYS MISS HENRY HUDSON.** While standing on a replica of the *Half Moon*, Brownlee presents an award to supervisor Buzzy Fitzsimmons as Billy Faier looks on. Brownlee championed many local causes, most recently, a horse named Magic who patrolled Woodstock's streets in the 1990s. Not one to take supervisor Mower's "no" for an answer, Gale raised $9,000 for Magic's purchase. (Courtesy Gale Brownlee.)

119

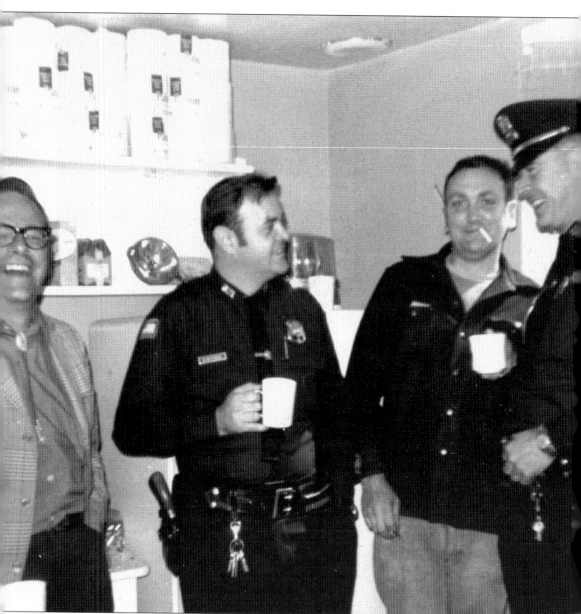

**WOODSTOCK CONSTABLES ON COFFEE BREAK c. 1974.** Pictured here, from left to right, are Warren Graver, Bill Waterous, Alan VanWagenen, and Lud Baumgarten. Local men were hired as constables or peace officers. They often walked foot patrol in pairs around the center of town, especially on summer evenings. They knew most of the kids hanging in town and acted as ombudsmen and social workers. (Author's collection.)

**REHEARSING *Woodstock Confidential.*** Bill West and Carol Cashdollar stand left of center stage while preparing to perform in a foundation play. Bobby Williams is in the white blouse. For over 10 years, the thespians contributed their time to support a fund for local artists. Artisans would apply for a grant from the organizers to help meet their expenses. (Courtesy Kiki Randolf.)

**ZENA BOYS PREPARING FOR THE PARADE.** Pictured from left to right are Dick Mellert, Dave Mellert, and Herb Vogel. Young people growing up in Zena did not participate in many youth activities held in the village. The one-room schoolhouse created a social barrier of sorts. When students graduated from eighth grade, they would meet their peers from the other hamlet schools, often for the first time. (Courtesy Gayle Donoghue.)

THE WOODSTOCK ROYALS AT ANDY LEE FIELD c. 1955. Pictured here are, from left to right, as follows: (on the ground) Allen Waterous, (front row) Herb Waterous, Peter Cooper, ? Berkowitz, Joe Hilton, Carl Van Wagenen, and coach Walter Van Wagenen; (back row) Bill Waterous, unidentified, ? Berkowitz, Rich Hilton, Bruce Reynolds, and Skip Mayhew. (Courtesy Joe Holdridge.)

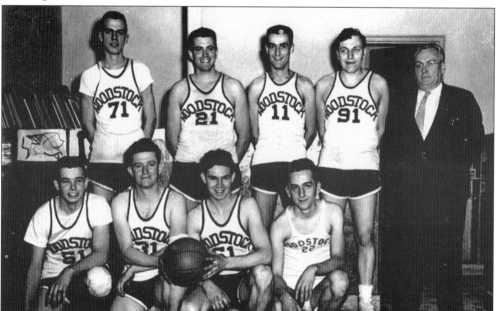

THE MEN'S WOODSTOCK TRAVELING TEAM. Pictured here are, from left to right, as follows: (front row) Rich Hilton, two unidentified, and Bob Kaiser; (back row) Pete Koehn, Bill Kleine, Ken Harder, unidentified, and coach Walter Van Wagenen. The youth today have different interests. Little League, soccer, and skateboarding have made tremendous gains in popularity. (Courtesy Kiki Randolf.)

**1976 BICENTENNIAL CELEBRATION.**
Pictured is Russ Roefs with the time capsule that was part of the Bicentennial Celebration. The chamber of commerce sponsored a collection of artifacts to be placed in the time capsule. The capsule was buried somewhere within the village green and will rest quietly until it is unearthed in 2026. (Author's collection.)

**KIKI RANDOLF BY INFORMATION BOOTH.** At one time, this building was near the Woodstock Playhouse at the 375 intersection. After the playhouse fire, the chamber moved the information booth to the center of town, on the site of the former Longyear house. A chamber of commerce has been active in some way or another in Woodstock for over 50 years. (Courtesy Kiki Randolf.)

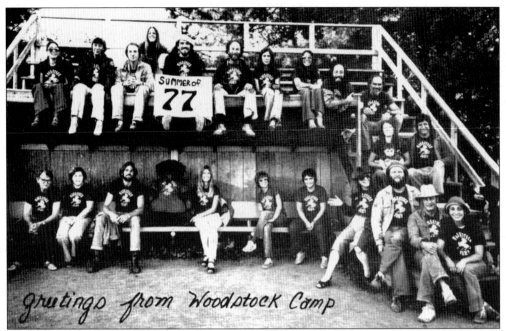

**WOODSTOCK CAMP AT THE ANDY LEE FIELD, 1977.** Pictured here are, from left to right, as follows: (front row) ? Weiss, Richard Miller, ? Weiss, three unidentified, the "rainbow man," Ted Scleris, and his wife; (back row) two unidentified, Bill Lubinsky, Marcia Weiss, Robert DePew Reynolds, Jay Wenk, four unidentified, Susan Goldman, and Dick Goldman. Shirts were printed for the campers and distributed throughout town. (Author's collection.)

**GILL TRNKA AND JOHN BROWN.** Trnka and Brown were well respected on either side of the bar at the Sea Horse and rode herd on a rowdy crowd at a very lively night spot. Jean Gaede recalls when Dick Stillwell closed the bar during World War II and gave the kids permission to create a youth canteen in its place. (Courtesy Kiki Randolf.)

**KIKI RANDOLF, CHARLIE RAIBLE, AND FRAN TRNKA AT THE SEA HORSE.** The man who is third from left is unidentified, although he is believed to be a Rotron associate of Charlie Raible's. There was a Ping-Pong table in one corner that saw constant action. (Courtesy Kiki Randolf.)

**SOCIALIZING AT THE IRVINGTON.** Though the patrons are unidentified, you can not miss Bill Dixon hiding behind the cash register. Scotty McAdams appeared nightly on the piano. There is a shuffleboard table in the left-hand corner waiting for a group of bowlers to play. Some 50 years later, the television and the phone booth are in the same location. (Courtesy Stan Longyear.)

**THE VILLAGE JUGS.** Wives and girlfriends of the men's softball league challenged the men's team to a Sunday game. They planned to use all possible means to divert the men's concentration. Pictured are, from left to right, as follows: (front row) Rose Curry, Lyn Breitenstein, Denise Clark, Teri Trippico, and Pam ?; (back row) Lori Waterous, Janine Mower, Karen Bryant, Georgene Fredericks, ? Ticefelt, Cindy Van Wagenen, Karen ?, ? Ticefelt, and Debbie Holsapple. (Author's collection.)

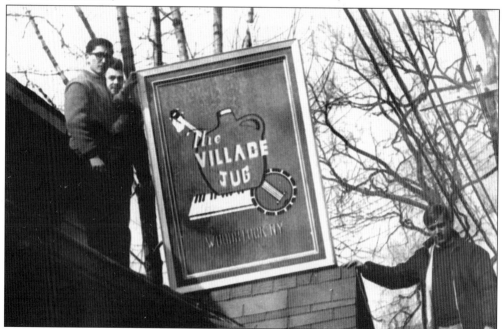

**THE VILLAGE JUG.** The next generation of entrepreneurs opens in the former Shannon's Bar on Rock City Road. Dick Mellert (far left), Bill Beesmer (lower right corner), and their partners promoted the very popular Wednesday Peanut Night and Sunday morning Bloody Mary softball leagues. (Courtesy Kiki Randolf.)

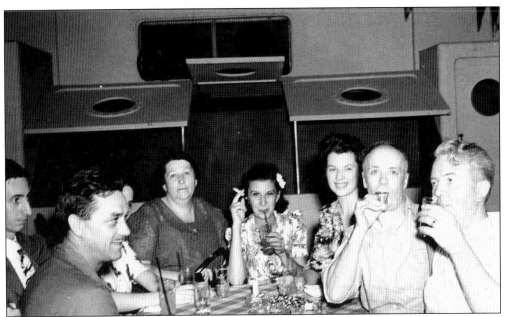

**OPEN PORTALS SIGNALING PARTY TIME.** Pictured here at the Sea Horse are, from left to right, as follows: Adolf Heckeroth, two unidentified, ? McFeeley, Doris Stowell, Edith McFeeley Heckeroth, Herb McFeeley, and Stowey Stowell. Local children were cautioned not to go in when the portals were open, as they might see something they shouldn't. (Courtesy Bill Heckeroth.)

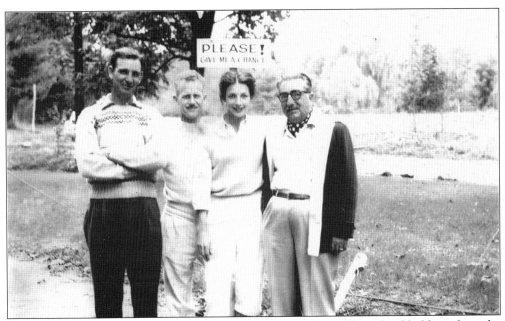

**HUTCH, DEANIE, KATHLEEN, AND TONY.** With the purchase of large land holdings from the heirs of the Aaron Riseley estate, Woodstock Property Inc. opened their first clubhouse in the old boarding house across from the former gristmill. Pictured here are the "pro," the popular restaurateur, a dynamic woman golfer, and the club's 21st-century mentor. (Courtesy Historical Society of Woodstock.)

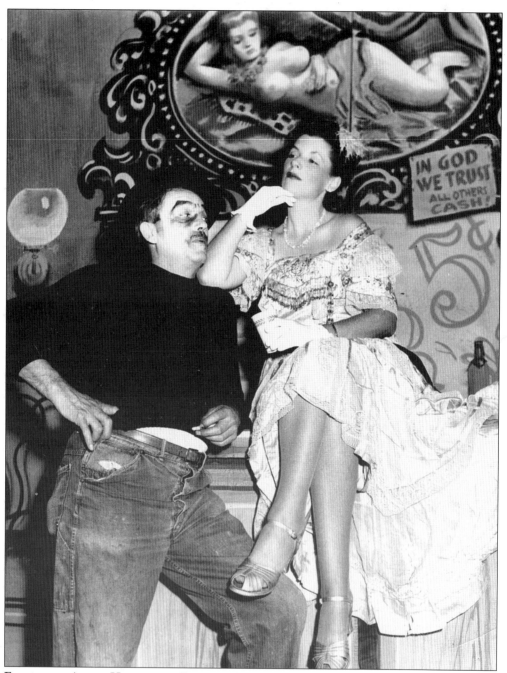

**EDITH AND ADOLF HECKEROTH POSE FOR A FOUNDATION PLAY PRESS PHOTO.** Edith, from Canada, and Adolf, from Germany, crossed all cultural and social lines. They wove themselves into the fabric of Woodstock's lively bar scene, budding art scene, and stormy local political scene. They owned a plumbing business and were trusted enough to have keys to many of the homes in Woodstock. The couple worked hard but they were not afraid to have fun. Perhaps their example holds the key for Woodstock's future. (Courtesy Bill Heckeroth.)